ART STUDENTS' ANATOMY

BY

EDMOND J. FARRIS

SECOND EDITION REVISED

PROFESSOR OF ANATOMY, PENNSYLVANIA ACADEMY OF THE
FINE ARTS; MEMBER, THE WISTAR INSTITUTE OF ANATOMY AND
BIOLOGY; DIRECTOR, THE FARRIS INSTITUTE FOR PARENTHOOD

158 ILLUSTRATIONS
DRAWINGS BY
L. AUGUSTA S. FARRIS

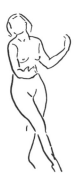 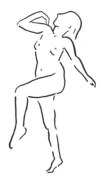

DOVER PUBLICATIONS, INC.
NEW YORK

Published in Canada by General Publishing Com-
pany, Ltd., 30 Lesmill Road, Don Mills, Toronto,
Ontario.
Published in the United Kingdom by Constable
and Company, Ltd., 10 Orange Street, London
WC 2.

This Dover edition, first published in 1961, is an
unabridged and unaltered republication of the sec-
ond edition, published by J. B. Lippincott Company
in 1935.

Standard Book Number: 486-20744-7

Library of Congress Catalog Card Number: A62-8634

Manufactured in the United States of America
Dover Publications, Inc.
180 Varick Street
New York, N. Y. 10014

TO MY MOTHER

PREFACE

The purpose of this book is to describe to art students in as simple a manner as possible the essential anatomy of the living body. In the study of anatomy, it is advisable for the student to master: first, the skeleton and its surface projections; second, the muscles and their surface projections; and third, the surface form as affected by various actions. The author hopes to assist the student in accomplishing this chiefly by illustrations, photographs of living models, and roentgenograms. Text is used only to emphasize the importance of illustrations.

Close observation of one's self, as well as of others at work and at play will prove exceedingly beneficial in the mastery of anatomy. When a living model is available, the student should observe most carefully the details of the surface anatomy, and should train himself to do memory sketches of the model using these details as a premise to assist the expression of the artist.

Our great masters of art realized that a thorough understanding of anatomy was a necessary instrument in the portrayal of art, and Leonardo da Vinci, though known as an artist, merits the reputation of a great anatomist by reason of his accurate anatomical sketches and contributions to this subject.

In this book are reproductions of the great work of Siegfried Albinus, an anatomic illustrator of the early 18th century. These muscle and skeleton plates have been described by Dr. Charles Singer "as the most beautiful and among the most accurate anatomical figures ever published." In order to have scientifically correct drawings, numerous figures were drawn from actual bodies, these carefully averaged, and the completed work engraved by Jan Wandelaar under Albinus's direction. Most interesting are the ornaments of his figures which were chosen to give an accurate idea of the proportions of the figures.

The roentgenograms in the nine figures show actual actions of joints, and the bones forming these joints. The detail of bone in these x-rays was avoided purposely by the author in an effort to show greater skin density, and thus, a better understanding of the relationship of the skin to the bones of the joint.

The anatomical terms used throughout the text are in current use today in the majority of anatomical laboratories, and should likewise be adopted by the artists. A glossary of terms, their pronunciations and meanings is given at the end of the book.

The author is indebted to his wife, L. Augusta Stroman Farris for her untiring efforts, care and skill in making all of the illustrations, and for useful advice in all branches of the work. My thanks are due Roy M. Reeve, photographer at the Army Medical Museum, and his staff of assistants, for their very fine cooperation in taking most of the photographs. To Ted Shawn, the author wishes to acknowledge and express appreciation for the use of two photographs. The author appreciates the cooperative assistance of all the persons who so kindly posed for the photographs. Appreciation is also extended Dr. Wilbur Davis for assisting the author in the photography of some of the action pictures in figures 141 and 142, and to Dr. Louis G. Farris, Dr. Felipe Martinez, and John Keohane for valuable criticism.

For the friendly dealings, and excellent cooperation, the author wishes to thank Mr. E. W. Bacon and the publishers, J. B. Lippincott Company.

PREFACE—Second Edition

Suggestions to the teacher and student

Various methods are used in art schools for the study of anatomy. In the lectures and work at the Pennsylvania Academy of the Fine Arts, I have endeavored to teach students to develop primarily keener powers of observation, and thus create a clearer insight in understanding the nature of the figures which the artist represents.

We follow closely the order of chapters in the book. We consider the landmarks and proportions very early in the course, for the student is constantly referring to landmarks and proportions in practically all of his work. The skeleton as a whole, the skull, bones and joints are studied in detail. Every student has a set of bones available for drawing purposes and to refer to during the lectures. The lecture is preceded and followed, as a rule, with approximately ten minutes of demonstration and sketching from the model, to emphasize the anatomy considered in the lecture. In the study of the muscular system, not only are the origin, insertion and action of each muscle stated, but the individual shapes of their fleshy and tendonous portions, and their effect on the surface forms are carefully demonstrated, when possible, on the living model.

Besides such visual aids as lantern slides and motion pictures, frequent visits are made to the galleries, to discuss the anatomy in all types of art. At the close of each semester, the students compete for three different prizes; one for the most complete and accurate set of bone drawings, two for the most accurate drawing of a skeleton which is posed, and three for the drawing of the most accurate muscle surface anatomy representation.

We have found that one of the advantages of this book is that the student is able to learn anatomy the easy way, for by referring constantly to the illustrations, one can identify anatomical structures such as muscles, bony landmarks, swellings or the parts of interest without the aid of a teacher.

It is a pleasure to acknowledge my thanks to a former student, Frank Stepler, for figures 144 and 145, and other anatomy students at the Pennsylvania Academy of the Fine Arts for samples of class work.

The Wistar Institute of
Anatomy and Biology

EDMOND J. FARRIS

CONTENTS

ART STUDENTS' ANATOMY

INTRODUCTION TO ANATOMY

Human Anatomy is the study of the architecture of the human body. The body is composed of several systems of organs as follows:

1. The **skeletal system**; or study of bones is known as **osteology.**
2. The **articulatory system**; or study of joints and ligaments is known as **arthrology.**
3. The **muscular system**; or study of muscles is known as **myology.**
4. The **nervous system**; or study of the brain and the spinal cord is known as neurology.
5. The **blood system**; or study of the lymph-vessels, heart, and blood vessels is known as **angiology.**
6. The **integumentary system**; or the study of skin, hair, nails, etc. is known as dermatology.
7. The **respiratory system** consists of the lungs, larynx, and windpipe.
8. The **digestive system** includes the alimentary canal and its accessory parts such as teeth, tongue, etc.
9. The **urogenital system** consists of the urinary and reproductive organs.

DESCRIPTIVE TERMS

In anatomical description, the following terms are in common use.

Anterior or **ventral** refers to the front of the body.
Posterior or **dorsal** refers to the rear or back of the body.
Superior or **cranial** refers to the head-end or upper-end of the body.
Inferior or **caudal** refers to the lower-end of the body.
Medial means nearer the midline of the body.
Lateral means farther from the midline of the body.
Internal means deeper or towards the center of the part.
External means towards the outside.

The terms **proximal** and **distal** are used only in description of the limbs.
Proximal means nearer the point of attachment or trunk, while **distal** means farther from the point of attachment.
The **anatomical position**, or the position in which the body is usually described, is one in which the individual stands erect, with arms at the side, and the palms of the hands facing forward.

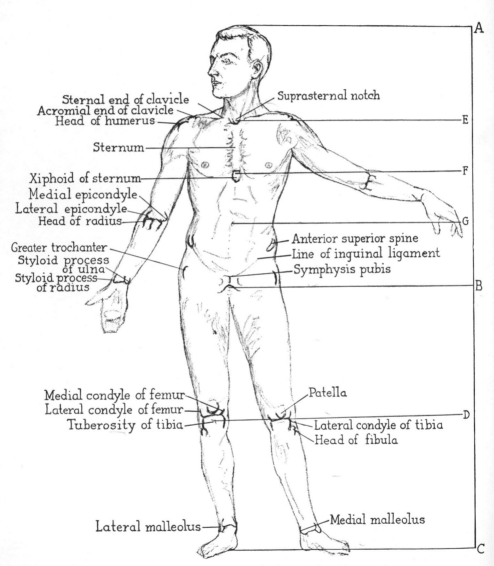

FIG. 1.—Anterior surface view showing landmarks and proportions.

CHAPTER I

LANDMARKS AND PROPORTIONS

There are landmarks evident in various regions of the body essentially important to the artist. These landmarks, as indicated in the figure on the opposite page, deal primarily with bones which cause projections on the surface. The details concerning the landmarks will be considered later in the text.

The human body is composed of the following parts:

The head (caput) includes the SKULL (cranium) and the FACE (facies). The face includes the mouth (os), nose (nasus), and eye (oculus).

The neck (collum) joins the head with the trunk. The sternocleidomastoid muscles, the throat (larynx), and the sternal parts of the clavicles are easily visible.

The trunk (truncus) is divided into the CHEST (thorax) and BELLY (abdomen). On the chest, one can distinguish the rib outline, the nipples of the mammary glands, and the lower border of the sternum, which serves as a line of separation between the thorax and abdomen. On the abdomen, the navel (umbilicus) is recognized as a depression at approximately the mid-abdomen. The inguinal ligament separates the trunk from the lower extremity. The BACK (dorsum) from the neck to the hip bones (coxae) is usually considered the hinder or posterior part of the trunk. The back of the neck is known as the nape (nucha).

The upper extremity (extremitas superior) is divided into four portions: SHOULDER (omos), ARM (brachium), FOREARM (antibrachium), and the HAND (manus), which includes the wrist (carpus).

The lower extremity (extremitas inferior) is also divided into four parts: HIP (coxa), THIGH (femur), LEG (crus), and FOOT (pes), which includes the ankle (tarsus).

PROPORTIONS IN THE ADULT MALE

The "head-length" is the usual unit of measurement.
The average body is 7½ heads in length.
The shoulders at the greatest width, measures about 2 head-lengths.
The supra-sternal fossa to the tip of the middle finger measures ½ the height of the body.

The body may be divided into two equal halves as in the diagram·
AB = BC where B represents the pubic arch.

3

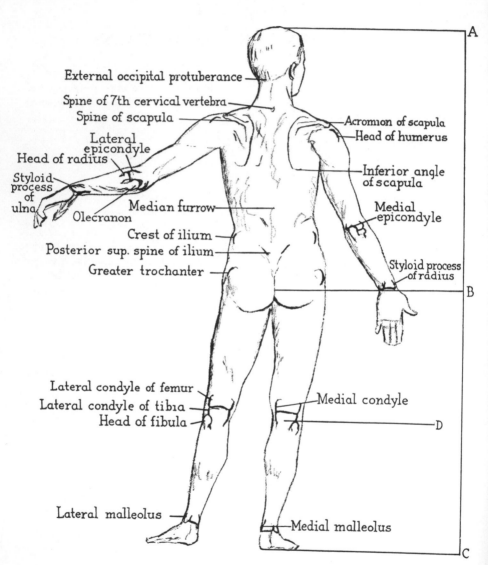

External occipital protuberance

Spine of 7th cervical vertebra

Spine of scapula

Acromion of scapula

Head of humerus

Lateral epicondyle

Head of radius

Inferior angle of scapula

Styloid process of ulna

Medial epicondyle

Median furrow

Olecranon

Crest of ilium

Posterior sup. spine of ilium

Greater trochanter

Styloid process of radius

Lateral condyle of femur

Lateral condyle of tibia

Head of fibula

Medial condyle

Lateral malleolus

Medial malleolus

Fig. 2.—Posterior surface view showing landmarks and proportions.

The lower half (BC) may be subdivided into two equal halves:
BD = DC where D represents a point just below the knee.

The trunk (Fig. 1) may be divided into equal thirds as follows:
EF = FG = GB where E is the supra-sternal fossa
 F is the xiphoid process of sternum
 G is the navel
 B is the pubic arch.

PROPORTIONS IN THE ADULT FEMALE

The body is 7½ head-lengths. The trunk is slightly greater in length than that of the male, while the length of the lower limbs is slightly shorter. The pelvis is broader in the female, while the width of the shoulders is narrower.

PROPORTIONS IN THE INFANT

The proportions of the infant may be represented in head-lengths as follows:

Birth—1st year 4 head-lengths
4 years 5 head-lengths
9 years 6 head-lengths (see page 125)
15 years 7 head-lengths
(Adult 7½ head-lengths)

CHAPTER II

THE SKELETON AS A WHOLE

The skeleton forms the framework of the body. It includes bones, cartilages, and articulations which bind the bones together.

Functions of Bones.
1. To afford surface for attachment of muscles.
2. To afford protection.
3. To serve as levers.
4. To bear weight.

Shape of Bones. The bones, according to their shapes, are divided into four types:
1. Long bone—Example, humerus.
2. Short bone—Example, wrist bones.
3. Flat bone—Example, scapula.
4. Irregular—Example, vertebra.

Sex of Bones. The male bones are characterized by:
1. Greater development of processes and ridges.
2. Greater broadness.
3. Greater size of the articular surfaces.

Number of Bones. It is impossible to state an exact number of bones for skeletons in general. No two skeletons are identical. However, two hundred separate bones (206) is the usual number of bones, of which one hundred and twenty-six belong to the appendicular skeleton, and seventy-four to the axial skeleton.

Parts of Bones.

Canal—a tunnel.
Condyle—a rounded eminence with articular cartilage.
Crest—a sharp border of bone.
Epicondyle—a projection above a smooth articular surface.
Foramen—a hole.
Fossa—a depression.
Incisure—a notch.
Lip—margin of a groove.

Line—a low ridge.
Plane—a flat surface.
Process—any kind of projection.
Sinus—a cavity in bone with mucous membrane lining.
Spine—a sharp prominence.
Sulcus—a groove.
Trochlea—a pulley.
Tuberosity—a rounded eminence.

THE SKELETON OUTLINED

The skeleton may be outlined as follows:

> AXIAL: Skull, Vertebrae, Sternum, Ribs, Hyoid bone.
> APPENDICULAR: Superior extremity, Inferior extremity.

Axial (Single bones) (Paired bones)

SKULL:

(Single bones)	(Paired bones)
frontal	parietal
ethmoid	temporal
sphenoid	zygoma (malar)
vomer	nasal
mandible	maxilla
occipital	palate
(hyoid)	lachrymal
	turbinate

VERTEBRAE:
cervical 7
thoracic 12
lumbar 5
sacrum 5 (Fuse to form one bone in adult)
coccyx 3 to 4 (Fuse to form one bone in adult)

STERNUM:
manubrium
body
xiphoid process

RIBS:
(Paired bones)
true ribs 14
false ribs 10

Appendicular (Appendicular skeleton is paired throughout)

SUPERIOR EXTREMITY:

clavicle or collar-bone
scapula or shoulder-bone
humerus or arm bone
radius ⎫
ulna ⎬ forearm
carpal or wrist bones (8)
metacarpal or palm bones (5)
phalanges or finger bones (14)

INFERIOR EXTREMITY:

innominatum or hip bone
 ilium
 ischium
 pubis
femur
tibia ⎫
fibula ⎬ leg
patella or knee-cap
tarsal bones (7)
metatarsal bones (5)
phalanges or toes (14)

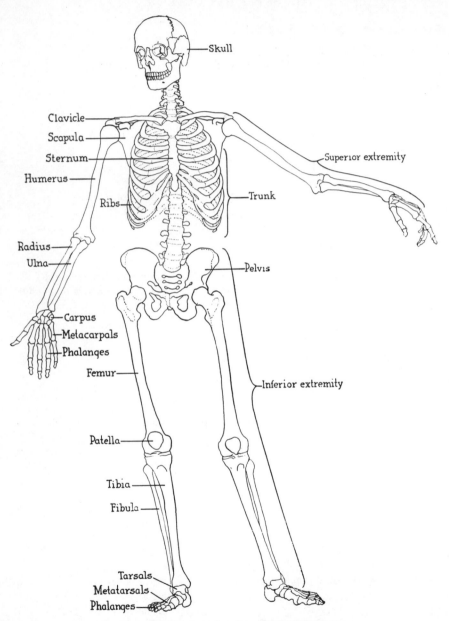

Skull

Clavicle

Scapula

Sternum

Humerus

Superior extremity

Ribs

Trunk

Radius

Ulna

Pelvis

Carpus

Metacarpals

Phalanges

Femur

Inferior extremity

Patella

Tibia

Fibula

Tarsals

Metatarsals

Phalanges

FIG. 3.—Skeleton, anterior view with labeled leaders.

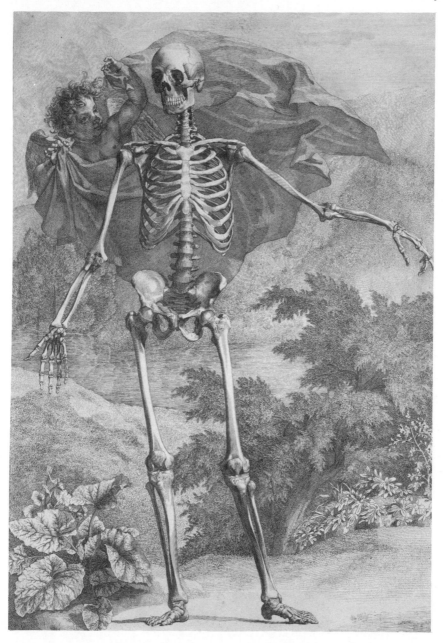

Fig. 4.—Skeleton, anterior view (Albinus).

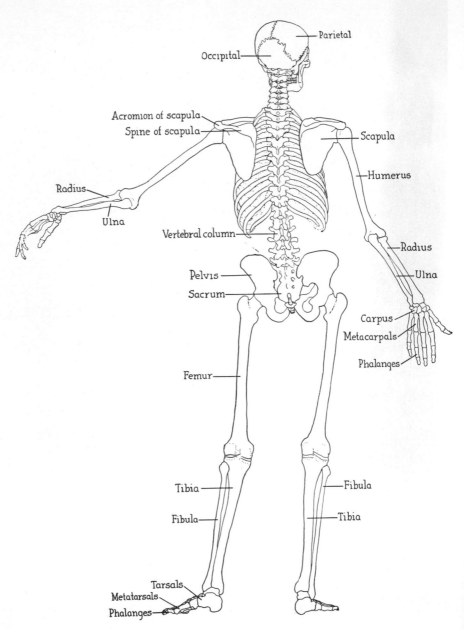

FIG. 5.—Skeleton, posterior view with labeled leaders.

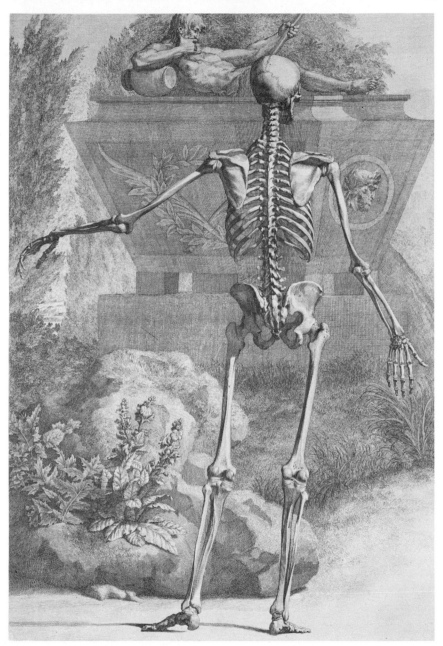

Fig. 6.—Skeleton, posterior view (Albinus).

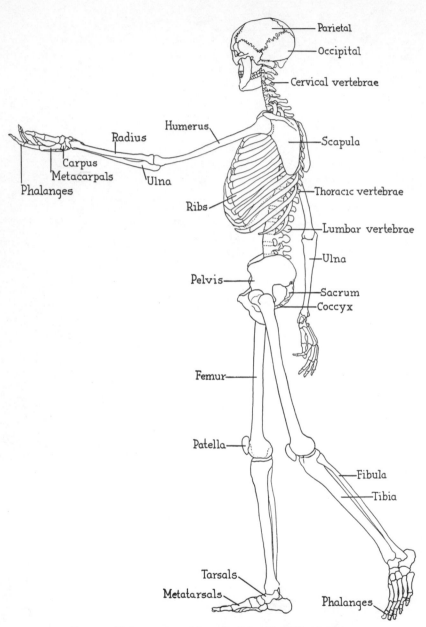

FIG. 7.—Skeleton, viewed from the left with labeled leaders.

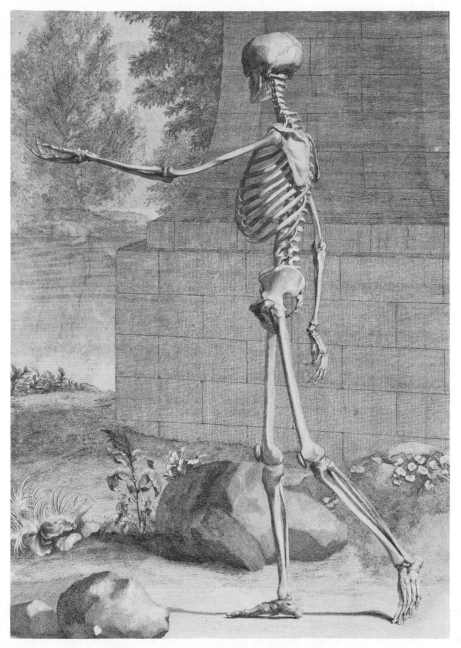

FIG. 8.—Skeleton, viewed from the left (Albinus).

CHAPTER III

THE SKELETAL SYSTEM

THE SKULL

The skull (Figs. 9, 10, 11) rests on the summit of the vertebral column. The individual bones composing the skull are joined to each other by sutures. The skull may be divided into two parts as follows: (1) the **skeleton of the face**, and (2) the **cranium**, in which the brain is lodged.

Skeleton of Face (14)	Cranium (8)
Two maxillae	Two parietals
Two nasals	Two temporals
Two zygomatics	Frontal
Two lacrimals	Occipital
Two palatines	Sphenoidal
Two inferior nasal conchae	Ethmoidal
Vomer	
Mandible	

The frontal bone forms the forehead, roof of the orbits, and the nasal fossae. It is smooth and subcutaneous, so that the shape of the bone is distinctive. The internal surface of the bone lodges the frontal lobe of the brain which is associated chiefly with the intellect. The frontal eminences are usually more prominent in women and children than in men, and appear as swellings on either side of the forehead. Below the frontal eminences are the superciliary arches which are small in the female and absent in children.

The occipital bone forms the back of the head. The **large foramen** (foramen magnum) on the base allows transmission of the spinal cord to the cranial cavity. The **external occipital protuberance** is easily felt as a prominent surface posteriorly. From the protuberance there extends laterally on either side a curved ridge of bone for muscle attachments, termed **superior nuchal line**.

The parietal bones are quadrilateral in shape and are united together in the mid-line by the sagittal suture to form the vault of the cranium.

The temporal bones are below the parietal bones at the side and base of the skull. Each possesses a nipple-like projection (the mastoid process), and a deep canal (the external auditory meatus of hearing). The mastoid process is not well developed in the infant, accounting for the marked flattening in appearance. (Fig. 144)

The maxillary bones are fused to form the whole upper jaw. Each maxilla assists in forming the roof of the mouth, the floor and lateral wall of the nose, and the floor of the orbits. It lodges the upper teeth, which in the adult consist of permanent teeth. The first set of teeth appear in childhood, and are called deciduous or milk teeth.

The dental formulae may be represented as follows (Figs. 9, 10, 11, 144):

	Molar	Premolar	Canine	Incisor	Incisor	Canine	Premolar	Molar
Permanent	3	2	1	2	2	1	2	3
Deciduous		2	1	2	2	1	2	

The mandible is the largest and strongest bone of the face. It consists of a horizontal body and two perpendicular parts, the rami, which unite with the ends of the body in the adult at nearly right angles. It lodges the lower teeth and has a dental formula identical to the upper jaw. The mandible articulates with the temporal bone.

The zygomatic bones are small and quadrangular in shape and are situated at the upper part of the face to form the distinct prominences of the cheeks.

The two nasal bones form the bony arch or "the bridge" of the nose by being placed side by side at the middle and upper part of the face.

The sinuses are large air spaces in the frontal, ethmoid, sphenoid, and maxillary bones. They all communicate with the nasal passages.

Differences in skull due to age—see page 149.

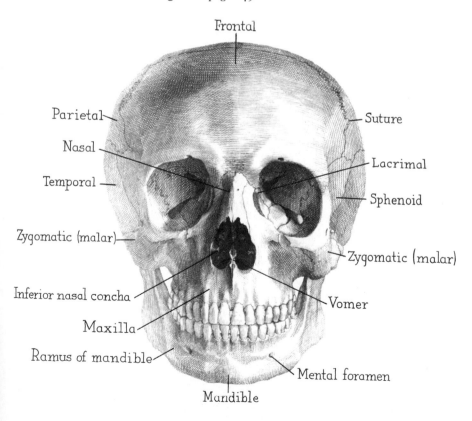

Frontal

Parietal

Nasal

Temporal

Zygomatic (malar)

Inferior nasal concha

Maxilla

Ramus of mandible

Suture

Lacrimal

Sphenoid

Zygomatic (malar)

Vomer

Mental foramen

Mandible

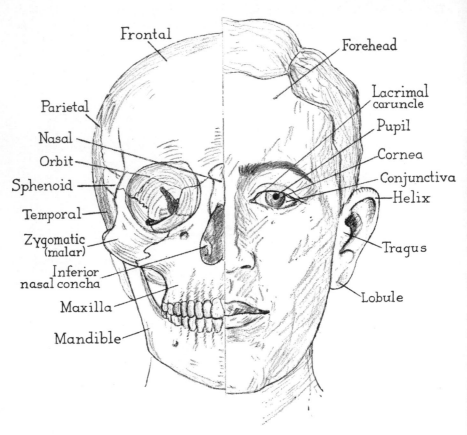

Fig. 10.—Skull from in front, showing surface relationships.

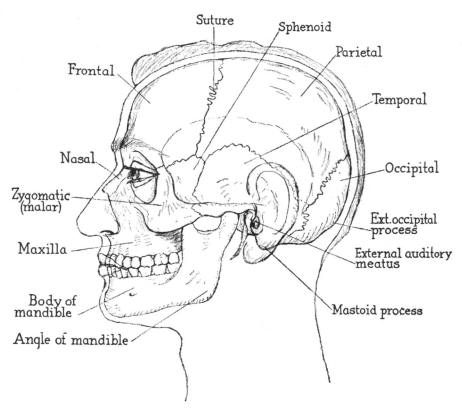

FIG. 11.—Skull from the left side, showing surface relationships.

THE VERTEBRAL COLUMN

The vertebral column forms the central axis of the skeleton. It is made up of twenty-six vertebrae in the adult as follows:

Cervical	7
Thoracic	12
Lumbar	5
Sacral	1
Coccygeal	1

The Spine. The spinal column is the chief support for the head, the ribs, the upper and lower extremities. The average length of the spine is about 28 inches in the male, and 27 inches in the female. The **true or movable part** of the spine is made up of the cervical, thoracic, and lumbar portions. The false or fixed part is made up of the sacrum and the coccyx. Spines of all vertebrae incline downwards, a condition peculiar to men and anthropoid apes. The greatest inclination is in the thoracic and least downward inclination is in the lumbar portions.

Curvatures. The vertebral column presents a series of curvatures as follows:

PRIMARY CURVES: THORACIC, convex dorsally, SACRAL, convex dorsally.
SECONDARY CURVES: CERVICAL, concave dorsally, LUMBAR, concave dorsally.
The thoracic and sacral curves are termed **Primary** because they are present in fetal life. The cervical and lumbar curves are **Secondary,** and are developed after birth at about three and one-half months, when the child holds up his head; at nine months, when the child sits upright; and at about twelve to eighteen months, when the child begins to walk.

BONY LANDMARKS

The **spines** of the vertebrae are subcutaneous. The **seventh cervical** or **vertebra prominens** is the most prominent in the **cervical region.** The **first thoracic spine** may appear more prominent than the seventh cervical. On stooping or bending, the **thoracic vertebrae** appear like beaded elevations.

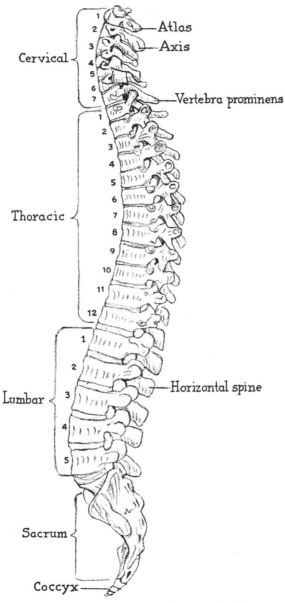

Cervical
1
2 —Atlas
3 —Axis
4
5
6
7 —Vertebra prominens

Thoracic
1
2
3
4
5
6
7
8
9
10
11
12

Lumbar
1
2
3 —Horizontal spine
4
5

Sacrum

Coccyx

FIG. 12.—Vertebral column, from the left side.

CLAVICLE

Shape. Slender, double curved, rounded medially, flattened laterally.
Position. Ventrally at base of neck and beginning of shoulder.
Articulations. Sternum, indirectly medially, acromion laterally.
Divisions. Body, sternal extremity, acromial extremity.

Bony Landmarks

The clavicle is subcutaneous throughout, being visible in most people, and easily felt through the skin and fascia. The sternal extremity is always visible.

STERNUM

Shape. Elongated, flattened ventro-dorsally, Roman sword-like.
Position. Thorax (chest), ventro-medially.
Articulations. Clavicle and true ribs.
Divisions. Manubrium (handle), body (little sword), xiphoid process.

Bony Landmarks

The middle of the sternum is subcutaneous. The female sternum is shorter and perhaps somewhat broader than that of the male.

THORAX
(Figures 4, 6, 8)

Shape. Barrel like, but smaller at upper than at lower portion.
Comprises. 12 thoracic vertebrae
 12 ribs and cartilages
 1 sternum (breast bone), which by their articulations make the barrel-shaped cavity. The slope of ribs increases from above downwards. The antero-posterior flattening is a purely human characteristic.

The upper seven ribs are called **true ribs** because they are attached to the sternum. The lower five ribs are called **false ribs** because they are not attached directly to the sternum, but by cartilage to the sternum. The eleventh and twelfth ribs are called **floating ribs** because they are free of cartilage. The thorax of the female is shorter than that of the male. Although the thorax is well covered externally with muscles, excepting the middle of the sternum and the mid-line of the back, the outline of the thorax is evident for the most part.

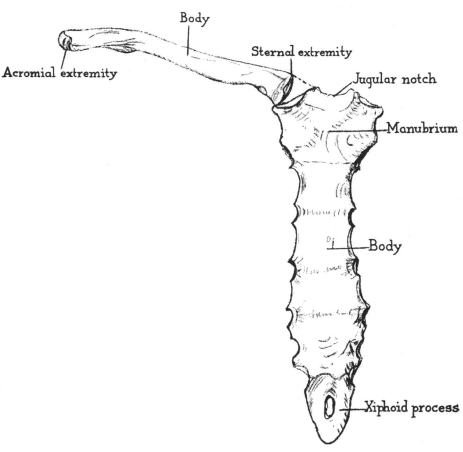

Body

Sternal extremity

Acromial extremity

Jugular notch

Manubrium

Body

Xiphoid process

FIG. 13.—Clavicle and sternum, from in front.

SCAPULA

Shape. Broad, flat, triangular with prominent transverse ridge on posterior side.
Position. Thorax, dorso-laterally from 2nd to 7th rib.
Articulations. Clavicle proximally, humerus distally.
Divisions. Body, spine, coracoid process, acromion.

BONY LANDMARKS

The bony points which can be felt on the scapula are the **acromion**, **spine, coracoid process,** the **vertebral border,** and the **inferior angle.**

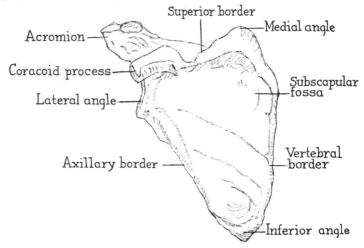

FIG. 14.—Right shoulder blade, scapula, from in front.

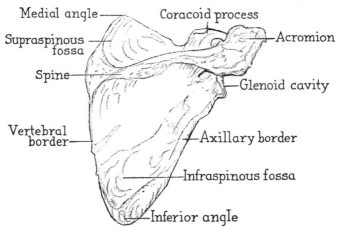

FIG. 15.—Right shoulder blade, scapula, from behind.

HUMERUS

Shape. Long, more or less round in upper half, triangular in lower half.
Position. Upper arm.
Articulations. Scapula, proximally, ulna and radius, distally.
Divisions. Body, proximal extremity, distal extremity.

BONY LANDMARKS

The **medial** and **lateral epicondyles** of the humerus are subcutaneous and easily recognized. The rest of the bone is covered with muscles, although a great part of it can be felt through them.

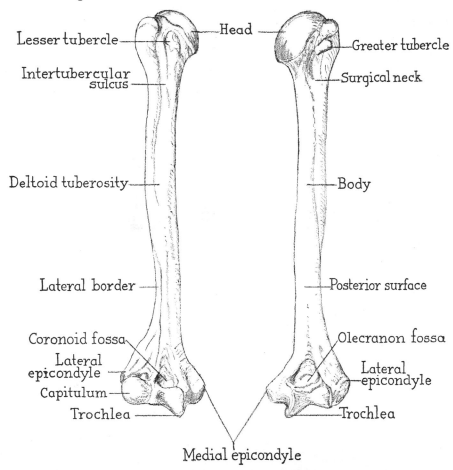

Lesser tubercle — Head — Greater tubercle
Intertubercular sulcus — Surgical neck
Deltoid tuberosity — Body
Lateral border — Posterior surface
Coronoid fossa — Olecranon fossa
Lateral epicondyle — Lateral epicondyle
Capitulum — Trochlea
Trochlea
Medial epicondyle

FIG. 16.—Right humerus, anterior view. FIG. 17.—Right humerus, posterior view.

RADIUS AND ULNA

RADIUS

Shape. Long, slightly curved, rounded proximally, becoming larger distally and somewhat oval.

Position. LATERALLY in forearm.

Articulations. Humerus proximally, ulna proximo-medially, ulna disto-medially, navicular and lunate bones of wrist distally.

Divisions. Body, proximal extremity, distal extremity.

BONY LANDMARKS

The **head** of the radius is visible on the back of the forearm, while the distal extremity (**styloid process**) is somewhat prominent and very easily felt just above the wrist.

ULNA

Shape. Long, tapering, triangular proximally, rounded distally.

Position. MEDIAL side of forearm.

Articulations. Humerus proximally, radius proximally and laterally, radius distally and laterally, triangular cartilage distally.

Divisions. Body, proximal extremity, distal extremity.

BONY LANDMARKS

The **head** of the ulna appears as a rounded knob when the forearm is in the prone (palm down) position. The knob disappears in supination (palm up). The **styloid process** of the ulna is about one-half inch more proximal than the styloid process of the radius. The ulna may be felt from end to end on the back of the forearm, the olecranon being subcutaneous, prominent, and visible.

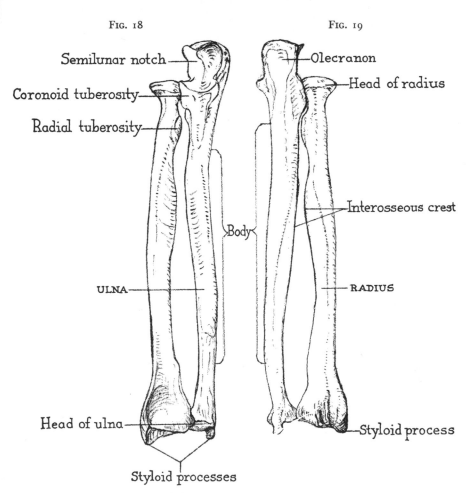

FIG. 18.—Bones of right forearm, radius and ulna, anterior view.

FIG. 19.—Bones of right forearm, radius and ulna, posterior view.

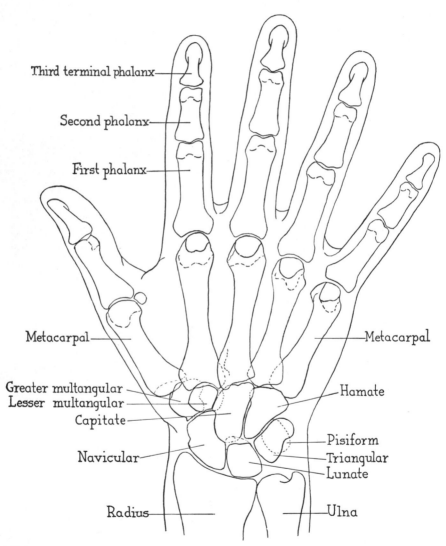

Third terminal phalanx

Second phalanx

First phalanx

Metacarpal

Metacarpal

Greater multangular
Lesser multangular
Capitate

Hamate

Pisiform
Triangular
Lunate

Navicular

Radius

Ulna

FIG. 20.—Tracing of roentgenogram of right hand, posterior view, showing bones labeled.

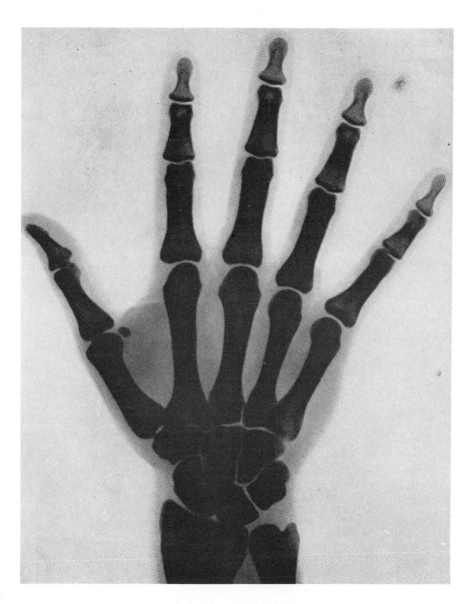

FIG. 21.—Roentgenogram of right hand, posterior view, showing bones.

PELVIS
(Figures 4, 6, 8, 22, 23)

Shape. Basin-like.

Position. Lower portion of trunk.

Comprises. Two hip-bones, the sacrum, and coccyx.

Differences in Sex. The male and female pelves differ greatly, because the latter is arranged for the function of child-bearing.

MALE	FEMALE
Bones stronger and heavier	Bones lighter
Superior aperture heart-shaped	Superior aperture oval
Minor pelvis deeper and narrower	Minor pelvis shallower and wider
Pubic arch pointed and narrow (60°)	Pubic arch rounded and wider (90°)

BONY LANDMARKS

The **anterior superior spine** is prominent in thin people, sometimes as a depression. The **iliac crest** is much more evident in front than behind, but can be felt throughout. The **posterior superior spine** (Fig. 49) forms the dimple evident usually in the female.

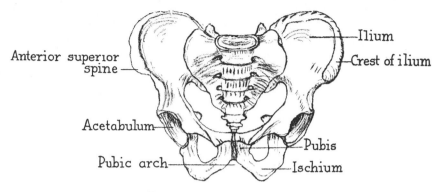

Ilium

Anterior superior
spine

Crest of ilium

Acetabulum

Pubic arch

Pubis

Ischium

FIG. 22.—Male pelvis, anterior view.

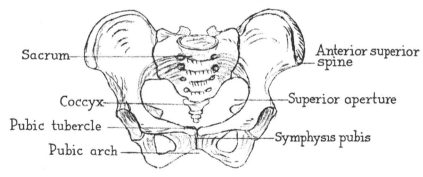

Sacrum

Coccyx

Pubic tubercle

Pubic arch

Anterior superior
spine

Superior aperture

Symphysis pubis

FIG. 23.—Female pelvis, anterior view.

FEMUR AND PATELLA

FEMUR

Shape. Long, large, rounded, slightly curved.
Position. Thigh.
Articulations. Pelvis proximally; tibia and patella, distally.
Divisions. Body, proximal extremity, distal extremity.

Bony Landmarks

The location of the greater trochanter is visible on the lateral surface of the hip. The lateral and medial epicondyles are both superficial.

PATELLA (Figures 4, 8)

Shape. Somewhat like a chestnut.
Position. Knee joint.
Division. Body.

Bony Landmarks

The form of the patella is visible under the skin and can be moved from side to side when the leg is extended and relaxed.

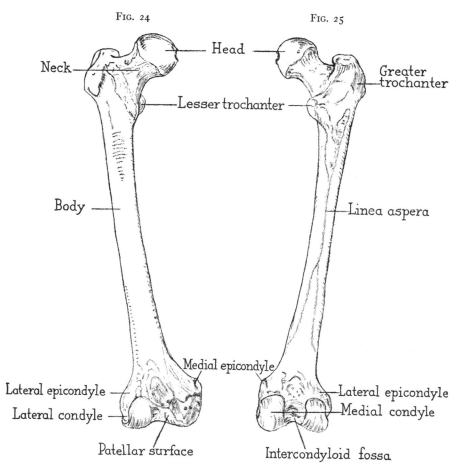

Fig. 24 Fig. 25

Neck — Head — Greater trochanter

Lesser trochanter

Body — Linea aspera

Medial epicondyle

Lateral epicondyle — Lateral epicondyle
Lateral condyle — Medial condyle

Patellar surface — Intercondyloid fossa

Fig. 24.—Right thigh bone, femur, anterior view.
Fig. 25.—Right thigh bone, femur, posterior view.

TIBIA AND FIBULA

TIBIA

Shape. Long, somewhat triangular, trumpet shaped.
Position. Medial side of leg.
Articulations. Femur proximally, fibula proximolaterally, talus and fibula distall:
Divisions. Body, proximal extremity, distal extremity.

BONY LANDMARKS

The medial surface of the tibia is subcutaneous and easily felt from proximal to distal ends. The tuberosity serves well as a landmark. The medial malleolus is also subcutaneous and visible, being noticeably higher than the malleolus of the fibula.

FIBULA

Shape. Long, slender, roughly or irregularly four sided.
Position. Lateral side of leg.
Articulations. Tibia, proximally; tibia and talus distomedially.
Divisions. Body, proximal extremity, distal extremity.

BONY LANDMARKS

The head of the fibula is seen as a bony prominence on the postero-lateral surface of the leg. Its distal quarter, including the lateral malleolus, is subcutaneous, the latter forming a somewhat triangular projection at the ankle.

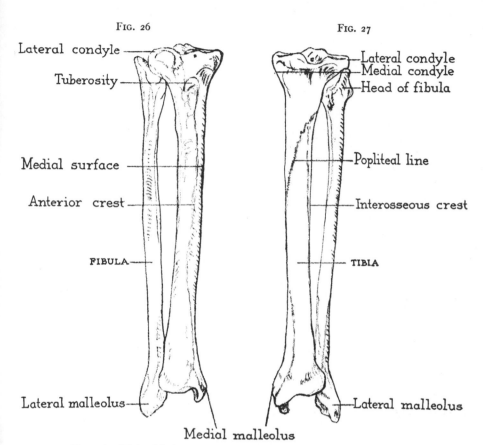

FIG. 26

FIG. 27

Lateral condyle

Tuberosity

Lateral condyle
Medial condyle
Head of fibula

Medial surface

Anterior crest

Popliteal line

Interosseous crest

FIBULA

TIBIA

Lateral malleolus

Lateral malleolus

Medial malleolus

FIG. 26.—Right shin bone and calf bone, tibia and fibula, anterior view.

FIG. 27.—Right shin bone and calf bone, tibia and fibula, posterior view.

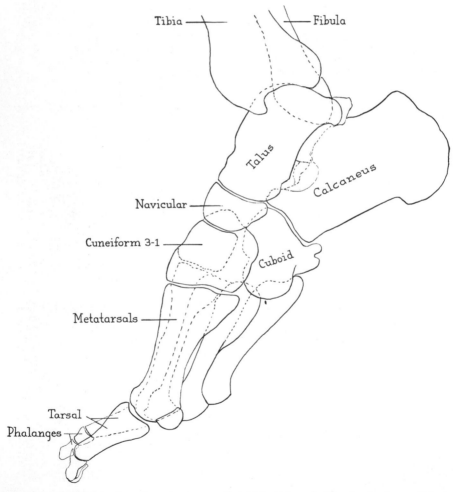

FIG. 28.—Labeled tracing of roentgenogram of right foot, from inside, showing bones of foot.

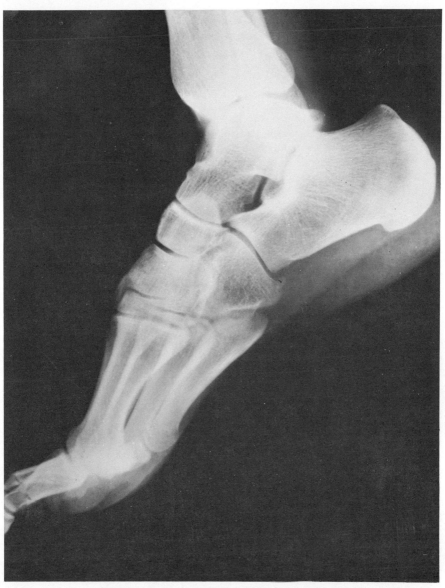

FIG. 29.—Roentgenogram of right foot, from inside, showing bones of foot.

CHAPTER IV

ARTICULATIONS AND MOVEMENTS

Articulations or joints are divided into three classes on the basis of possible movement.

1. Synarthrosis or **immovable.** Example: skull bones.
2. Amphiarthrosis, or **slightly movable.** Example: symphysis pubis.
3. Diarthrosis, or **freely movable.** Example: shoulder joint.

Typical Joint (Fig. 30). The freely movable joint includes the greater number of the joints important to the artist. This type of joint consists of:

1. CAPSULE, a continuous sheath of fibrous tissue which envelopes the articulating bones.

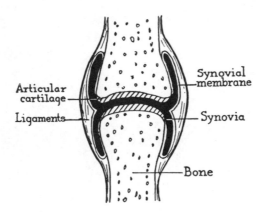

FIG. 30.—Diagram of a typical movable joint.

2. SYNOVIAL MEMBRANE, the inner lining of epithelial tissue which secretes a lubricating fluid.
3. SYNOVIA, a thick fluid enclosed in the joint capsule.
4. LIGAMENTS, thickened, tough, fibrous tissue outside the capsule where greater strain occurs.
5. ARTICULAR CARTILAGE, a cartilaginous surface which imparts smoothness.

36

MOVEMENT IN JOINTS

The movements in joints may be divided into four kinds as follows:

1. **Gliding:** one surface moving over another. Example: Carpal bones.
2. **Angular:**

 a. Movement away from median plane is called **abduction.**

 b. Movement toward the median plane is called **adduction.**

 c. Movement which increases the angle between the parts is called **extension.**

 d. Movement which decreases the angle between the parts is called **flexion.**

3. **Circumduction:** a succession of movements in which the part describes the surface of a cone, the apex of which is at the articulation.
4. **Rotation:** a movement around a central axis without any displacement from this axis.

SPECIAL MOVEMENTS

Of the Forearm—Supination, a movement which turns the forearm with palm upward.

Pronation, a movement which turns the forearm with the back of hand foreward.

Of the Ankle Joint—Inversion, a movement which turns sole of foot inward.

Eversion, a movement which turns sole of foot outward.

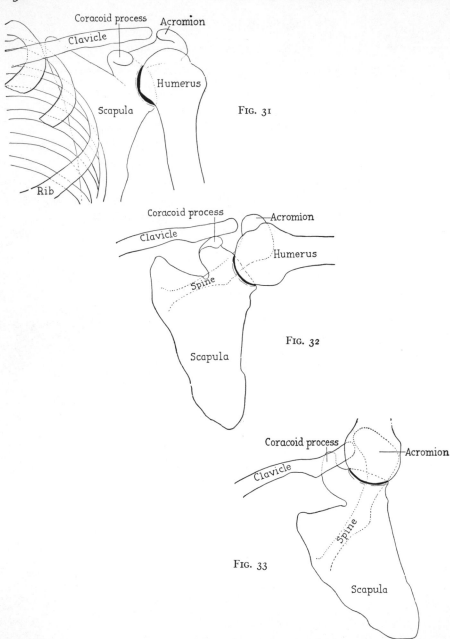

FIGS. 31, 32, and 33.—Labeled tracings of roentgenograms to show rotation of the scapula.

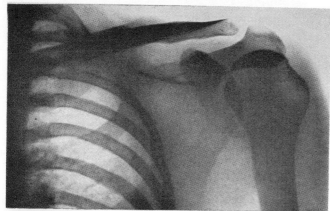

FIG. 34.—Roentgenogram of left shoulder, arm to side, front view.

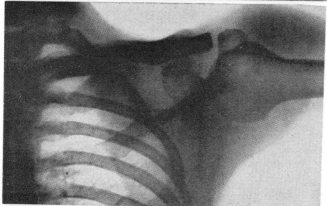

FIG. 35.—Roentgenogram left shoulder, arm abducted 90°.

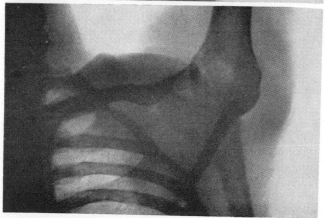

FIG. 36.—Roentgenogram left shoulder, arm extended overhead.

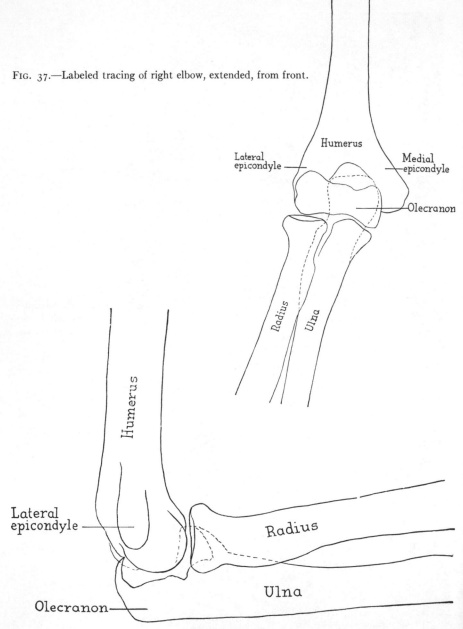

FIG. 37.—Labeled tracing of right elbow, extended, from front.

FIG. 38.—Labeled tracing of right elbow, bent 90°, from external side.

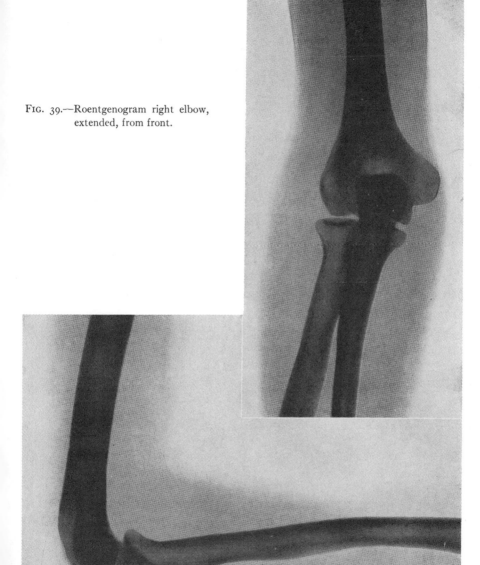

FIG. 39.—Roentgenogram right elbow, extended, from front.

FIG. 40.—Roentgenogram right elbow, bent 90°, from external side.

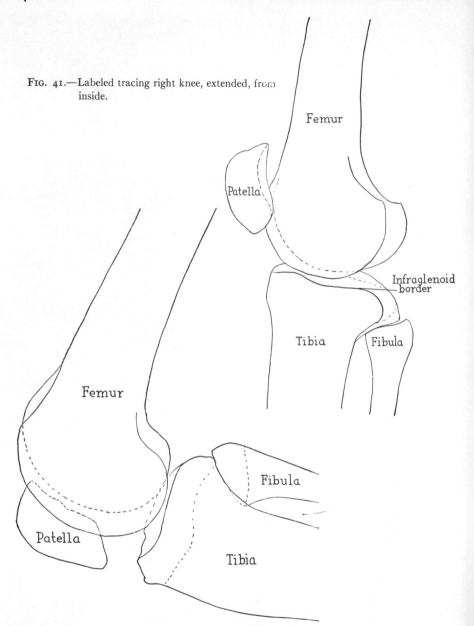

FIG. 41.—Labeled tracing right knee, extended, from
inside.

Femur

Patella

Infraglenoid
—border

Tibia Fibula

Femur

Fibula

Patella

Tibia

FIG. 42.—Labeled tracing right knee, bent 90°, from inside.

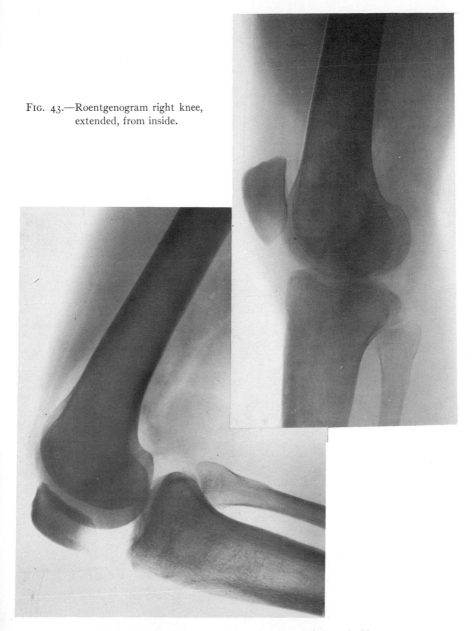

FIG. 43.—Roentgenogram right knee, extended, from inside.

FIG. 44.—Roentgenogram right knee, bent 90°, from inside.

CHAPTER V

BONY LANDMARKS ON THE HUMAN FIGURE

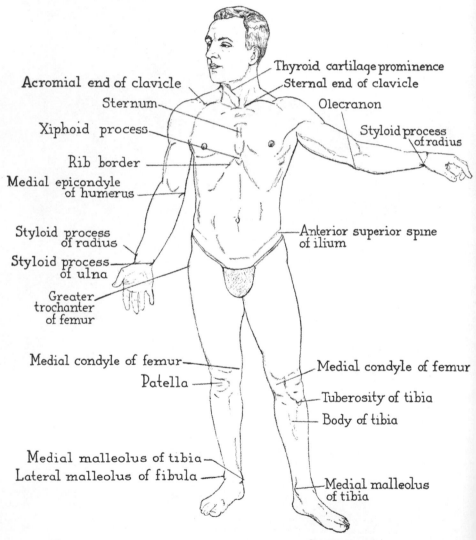

FIG 45.—Labeled sketch of male figure showing bony landmarks, anterior view.

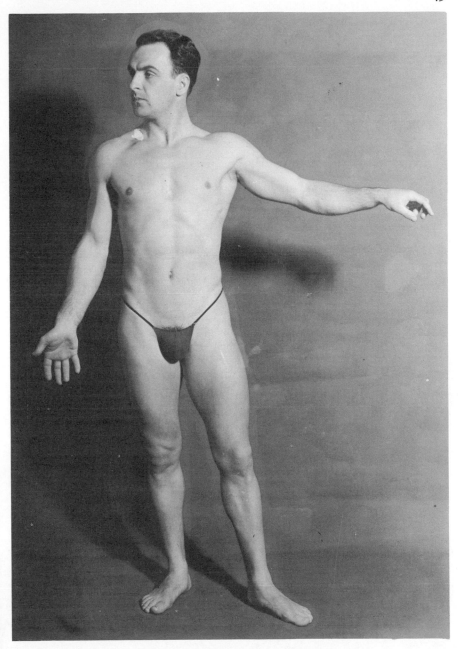

FIG. 46.—Male figure, anterior view.

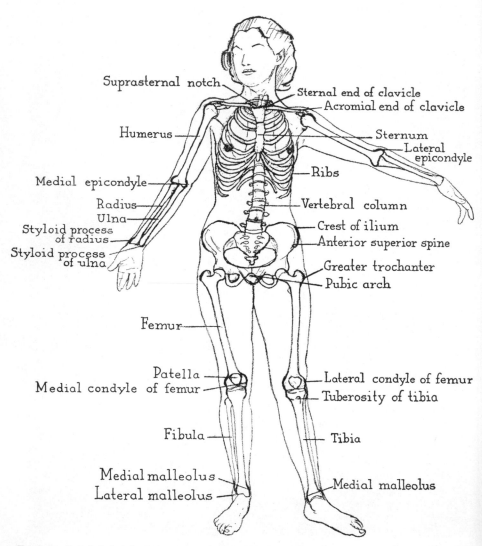

Suprasternal notch
Sternal end of clavicle
Acromial end of clavicle
Humerus
Sternum
Lateral epicondyle
Ribs
Medial epicondyle
Radius
Ulna
Vertebral column
Styloid process of radius
Crest of ilium
Anterior superior spine
Styloid process of ulna
Greater trochanter
Pubic arch
Femur
Patella
Medial condyle of femur
Lateral condyle of femur
Tuberosity of tibia
Fibula
Tibia
Medial malleolus
Lateral malleolus
Medial malleolus

FIG. 47.—Labeled sketch of female figure, showing relationships of the skeleton to surface form.

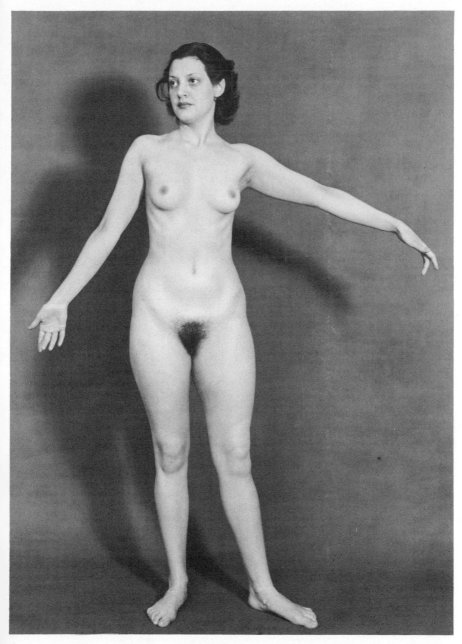

FIG. 48.—Female figure, anterior view.

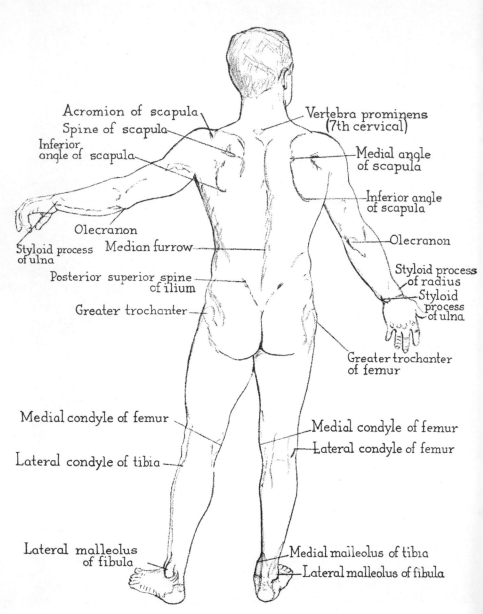

FIG. 49.—Labeled sketch of male figure showing bony landmarks, posterior view.

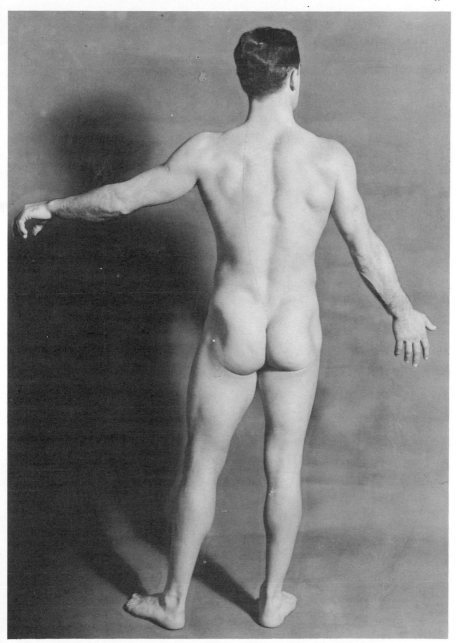

FIG. 50.—Male figure, posterior view.

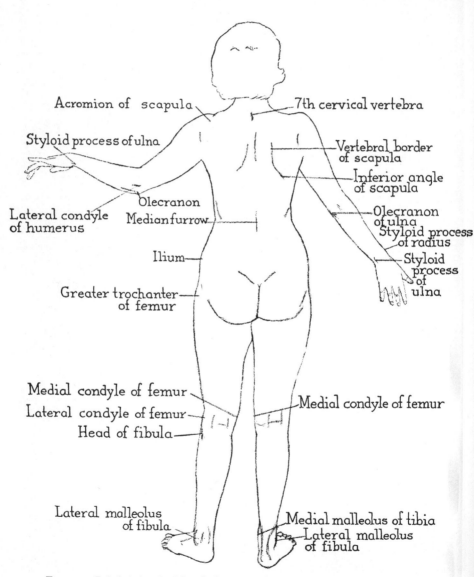

FIG. 51.—Labeled sketch of female figure showing bony landmarks, posterior view.

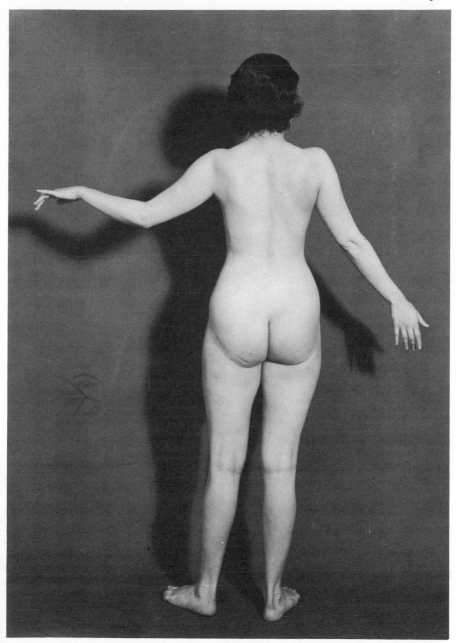

FIG. 52.—Female figure, posterior view.

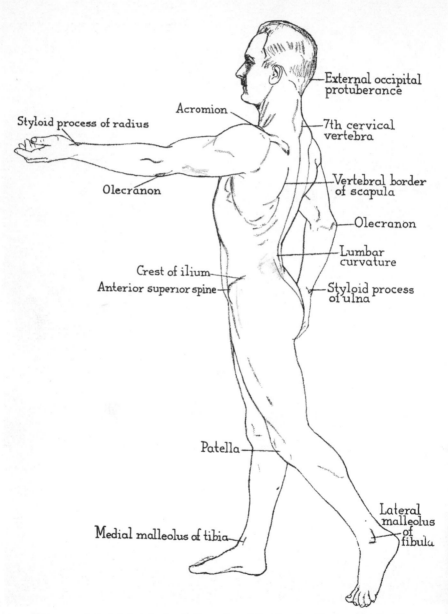

External occipital
protuberance

Acromion

7th cervical
vertebra

Styloid process of radius

Vertebral border
of scapula

Olecranon

Olecranon

Lumbar
curvature

Crest of ilium

Anterior superior spine

Styloid process
of ulna

Patella

Lateral
malleolus
of
fibula

Medial malleolus of tibia

FIG. 53.—Labeled sketch of male figure from left side, showing bony landmarks.

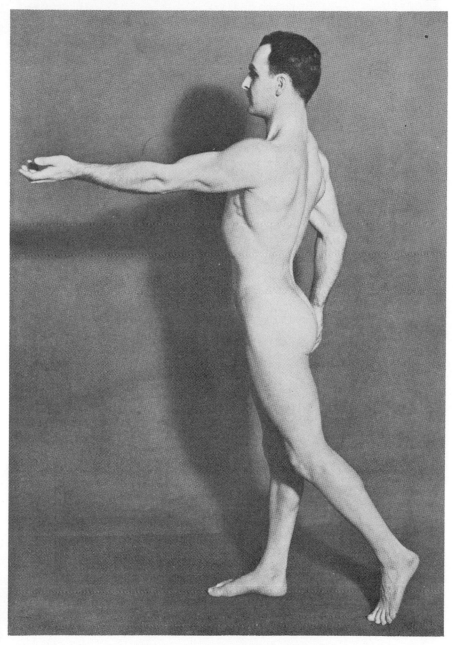

FIG. 54.—Male figure, left side view.

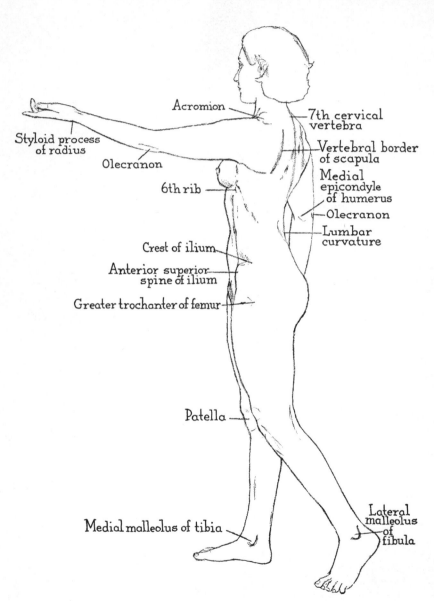

Acromion

7th cervical
vertebra

Styloid process
of radius

Olecranon

Vertebral border
of scapula

Medial
epicondyle
of humerus

Olecranon

6th rib

Lumbar
curvature

Crest of ilium

Anterior superior
spine of ilium

Greater trochanter of femur

Patella

Medial malleolus of tibia

Lateral
malleolus
of
fibula

Fig. 55.—Labeled sketch of female figure from left side, showing bony landmarks.

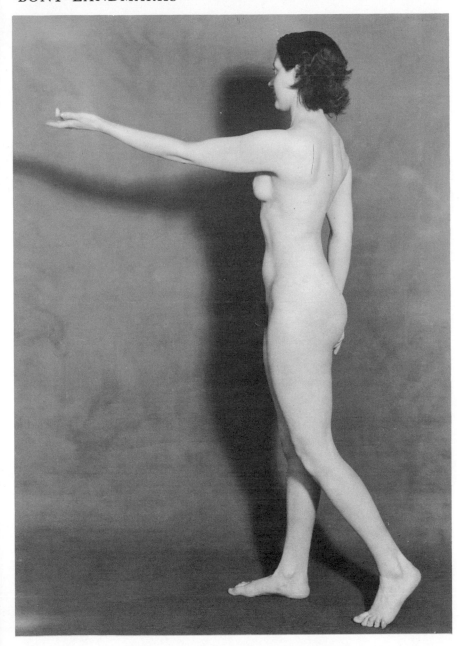

FIG. 56.—Female figure, left side view.

CHAPTER VI

THE MUSCULAR SYSTEM

The voluntary (skeletal) muscles constitute about forty-five per cent of the total body weight. The muscles act on the bones as levers, and move the different parts of the body. (Fig. 57.) In order for a muscle to contract, it must possess:

Origin—a relatively fixed point of attachment, and toward which the contraction is made.

Belly—which swells when a muscle is in action.

Insertion—a movable point of attachment.

Muscles possess also **three types of attachments:**

Direct to bone (usually the origin).

By tendon—which is a white, glistening, non-elastic, strong cord.

By aponeurosis—which is a sheet of white, flat connective tissue.

Name of Muscles. Muscles have received their names because of:
FORM—example, gracilis (slender).
ACTION—example, levator scapulae (raise the scapula).
SITUATION—example, frontalis (front of forehead).
ATTACHMENTS—example, coracobrachialis (coracoid process to arm).
STRUCTURE—example, triceps (three heads).
FUNCTION—example, flexor (to bend).
DIRECTION—example, obliquus.
OCCUPATION—example, buccinator (trumpeter's muscle).

ACTIONS OF MUSCLES

Muscles act across joints (Fig. 57), usually in combination with others for most movements. When one muscle or group of muscles contract, others must relax to allow the movement to be carried through. Therefore, no muscle acts purely by itself; the more complicated muscular actions are always in perfect harmony.

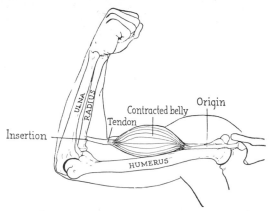

FIG. 57.—Diagram showing contraction of biceps brachii muscle.

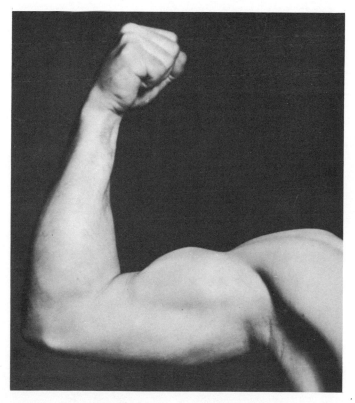

FIG. 58.—Flexed right arm, showing contraction of the biceps brachii muscle.

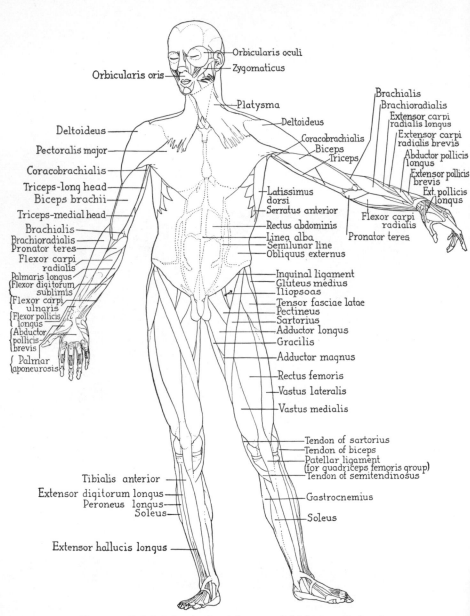

Orbicularis oculi
Zygomaticus
Orbicularis oris
Platysma
Deltoideus
Brachialis
Brachioradialis
Extensor carpi radialis longus
Coracobrachialis
Extensor carpi radialis brevis
Biceps
Triceps
Abductor pollicis longus
Extensor pollicis brevis
Ext. pollicis longus
Deltoideus
Pectoralis major
Coracobrachialis
Triceps-long head
Biceps brachii
Triceps-medial head
Brachialis
Brachioradialis
Pronator teres
Flexor carpi radialis
Palmaris longus
Flexor digitorum sublimis
Flexor carpi ulnaris
Flexor pollicis longus
Abductor pollicis brevis
Palmar aponeurosis
Latissimus dorsi
Serratus anterior
Rectus abdominis
Linea alba
Semilunar line
Obliquus externus
Flexor carpi radialis
Pronator teres
Inquinal ligament
Gluteus medius
Iliopsoas
Tensor fasciae latae
Pectineus
Sartorius
Adductor longus
Gracilis
Adductor magnus
Rectus femoris
Vastus lateralis
Vastus medialis
Tendon of sartorius
Tendon of biceps
Patellar ligament (for quadriceps femoris group)
Tendon of semitendinosus
Tibialis anterior
Extensor digitorum longus
Peroneus longus
Soleus
Gastrocnemius
Soleus
Extensor hallucis longus

FIG. 59.—Labeled sketch of muscles, superficial layer, anterior view.

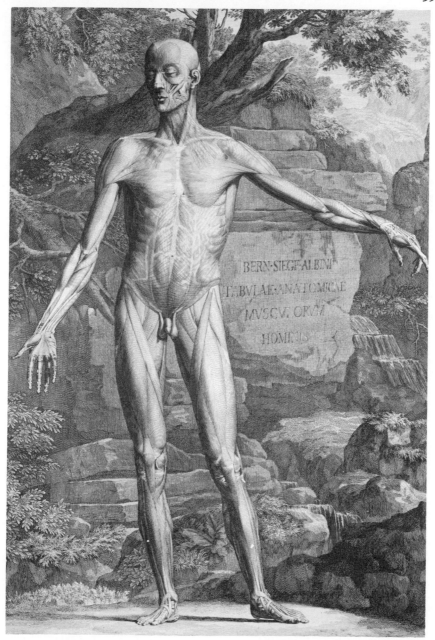

FIG. 60.—Muscles, superficial layer, anterior view. (Albinus.)

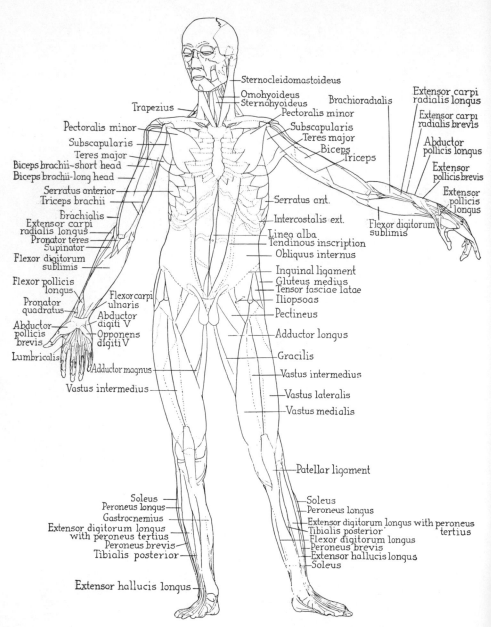

Sternocleidomastoideus
Omohyoideus
Sternohyoideus
Brachioradialis
Trapezius
Pectoralis minor
Pectoralis minor
Subscapularis
Subscapularis
Teres major
Teres major
Biceps
Biceps brachii–short head
Triceps
Biceps brachii–long head
Serratus anterior
Serratus ant.
Triceps brachii
Brachialis
Intercostalis ext.
Extensor carpi radialis longus
Linea alba
Pronator teres
Tendinous inscription
Supinator
Obliquus internus
Flexor digitorum sublimis
Inquinal ligament
Flexor pollicis longus
Gluteus medius
Tensor fasciae latae
Pronator quadratus
Iliopsoas
Flexor carpi ulnaris
Pectineus
Abductor pollicis brevis
Abductor digiti V
Opponens digiti V
Adductor longus
Lumbricalis
Gracilis
Adductor magnus
Vastus intermedius
Vastus intermedius
Vastus lateralis
Vastus medialis

Extensor carpi radialis longus
Extensor carpi radialis brevis
Abductor pollicis longus
Extensor pollicis brevis
Extensor pollicis longus
Flexor digitorum sublimis

Patellar ligament

Soleus
Soleus
Peroneus longus
Peroneus longus
Gastrocnemius
Extensor digitorum longus with peroneus tertius
Extensor digitorum longus with peroneus tertius
Tibialis posterior
Peroneus brevis
Flexor digitorum longus
Tibialis posterior
Peroneus brevis
Extensor hallucis longus
Extensor hallucis longus
Soleus

FIG. 61.—Labeled sketch of muscles, deep layer, anterior view.

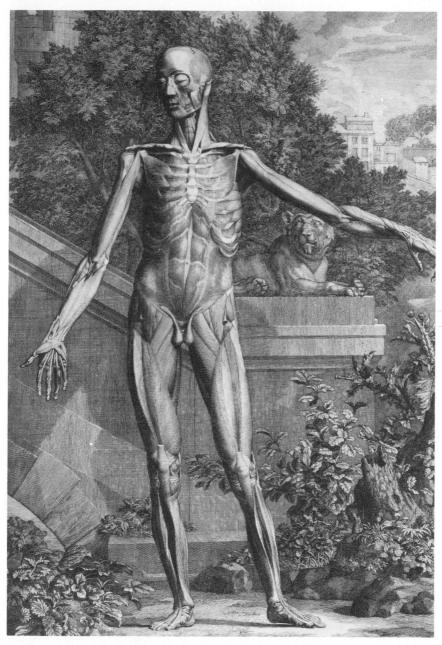

FIG. 62.—Muscles, deep layer, anterior view. (Albinus.)

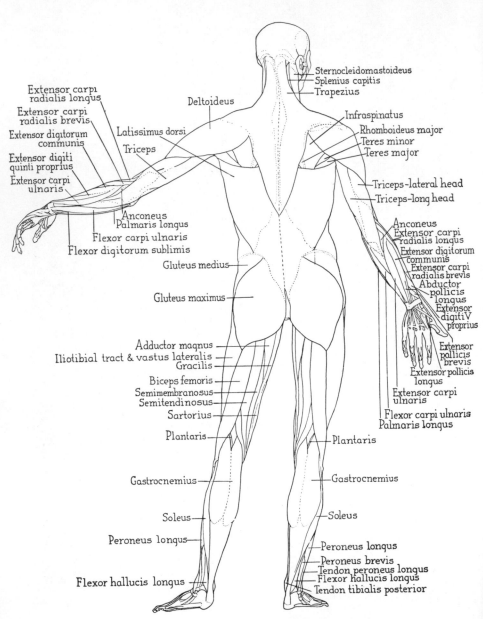

FIG. 63.—Labeled sketch of muscles, superficial layer, posterior view.

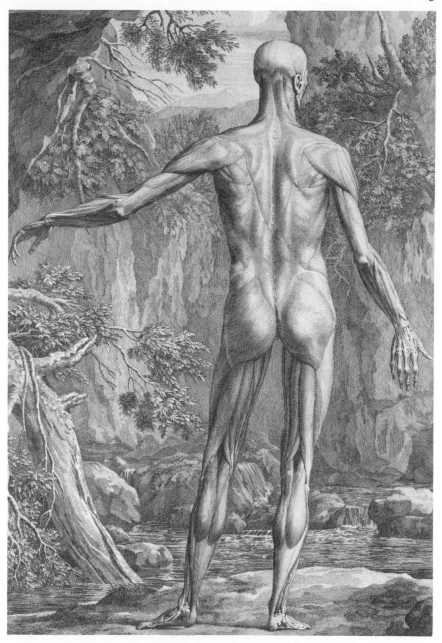

FIG. 64.—Muscles, superficial layer, posterior view. (Albinus.)

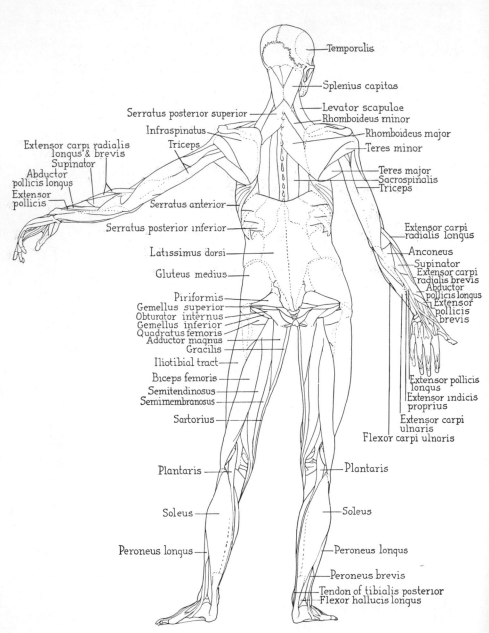

FIG. 65.—Labeled sketch of muscles, deep layer, posterior view.

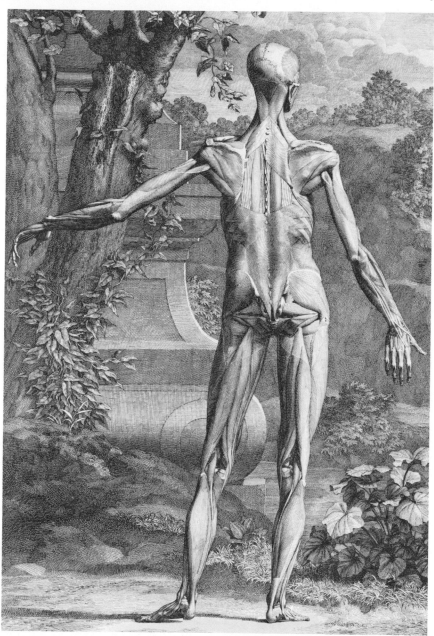

Fig. 66.—Muscles, deep layer, posterior view. (Albinus.)

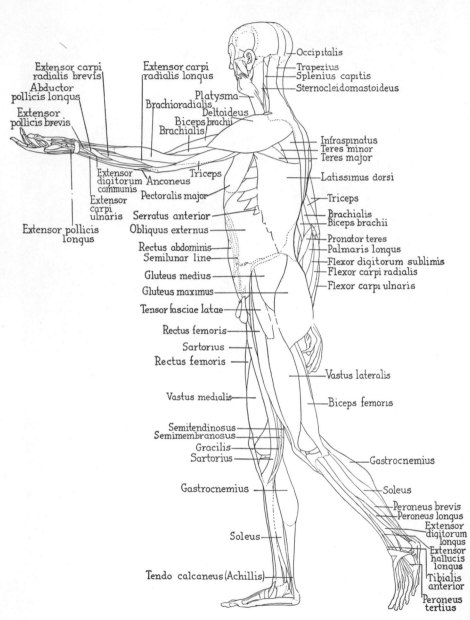

FIG. 67.—Labeled sketch of muscles, viewed from the left side.

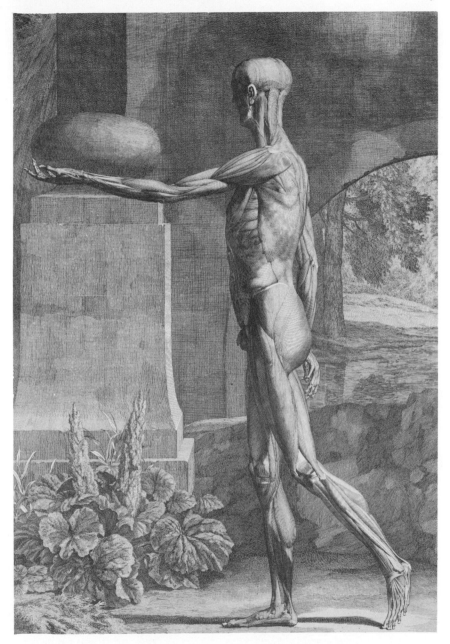

Fig. 68.—Muscles, viewed from the left side. (Albinus.)

MUSCLES SHOWN IN FIG. 69

MUSCLE	ORIGIN	INSERTION	ACTION
Auricularis anterior	Temporal fascia	Cartilage of ear	Draws ear forward
Auricularis superior	Epicranial aponeurosis	Cartilage of ear	Draws ear upward
Brachialis	Lower two-thirds of anterior surface cf humerus	Coronoid process of ulna	Flexes forearm
Brachioradialis	External epicondyloid ridge of humerus	In front of base of styloid process of radius	Flexes forearm and assists slightly in supination
Coracobrachialis	Coracoid process of scapula	Middle one-third of humerus	Adducts and flexes arm Assists in medial rotation
Extensor digitorum longus	Body and lateral condyle of tibia, upper anterior two-thirds of fibula by interosseous membrane	The four lateral toes	Dorsi-flexor of ankle; extensor of the four lateral toes
Flexor carpi ulnaris	Medial epicondyle of humerus, and ulnar head of olecranon process of ulna	Pisiform bone chiefly	Flexes and adducts the wrist; steadies pisiform bone; helps flex elbow joint
Flexor digiti quinti brevis	Hamate bone of wrist	First phalanx of little finger	Flexes first phalanx of little finger
Flexor pollicis brevis	Ulnar side of first metacarpal bone	Inner side base of first phalanx of thumb	Flexor of thumb; assists in opposing thumb to the fingers
Gracilis	Rami of pubis near symphysis	Shaft of tibia below medial condyle	Flexes knee; adducts thigh, rotates leg medially
Orbicularis oculi	Maxilla, frontal bone, and medial palpebral ligament	There is no bony insertion. The muscle fibres form a complete ellipse and terminate at the origin	Closes eye; draws eyelid towards median line; stretches skin of forehead
Orbicularis oris	Various muscles converging into the mouth	No bony insertion. Skin of lips	Draws lips together; helps in infinite variety of facial expressions as joy, grief, despair, etc.
Pectoralis major	Anterior medial half clavicle; sternum; cartilages of first six ribs; external oblique aponeurosis	Intertubercular sulcus of crest of humerus	Adducts, flexes, and rotates arm medially
Pectoralis minor	3rd to 5th ribs near anterior ends	Tip of coracoid process of scapula	Pulls scapula forward or ribs up
Platysma	Fascia covering pectoralis major and deltoid muscles	Inferior border of mandible; risorius muscle in corner of mouth	Depresses angle of mouth; wrinkles skin of neck in oblique direction; depresses lower jaw
Rectus abdominis	Symphysis and crest of pubis	Xiphoid process and 5-7 ribs	Draws thorax downward; flexes vertebral column and pelvis, supports abdominal viscera
Rectus femoris	Anterior inferior spine of ilium	Common tendon of quadriceps femoris or patella	Extensor of leg at knee; flexor of hip-joint; flexes body on hips
Sartorius	Anterior superior spine of ilium	Medial aspect of tuberosity of tibia	Flexes thigh and leg; rotates thigh laterally
Tibialis anterior	Upper outer two-thirds of tibia	First cuneiform and base of first metatarsal	Dorsi-flexion of ankle; helps invert foot
Zygomaticus	Zygomatic bone	Partly in skin about angle of mouth; partly into the orbicularis oris	Draws upper lip upward as in laughing; aids in other facial expressions

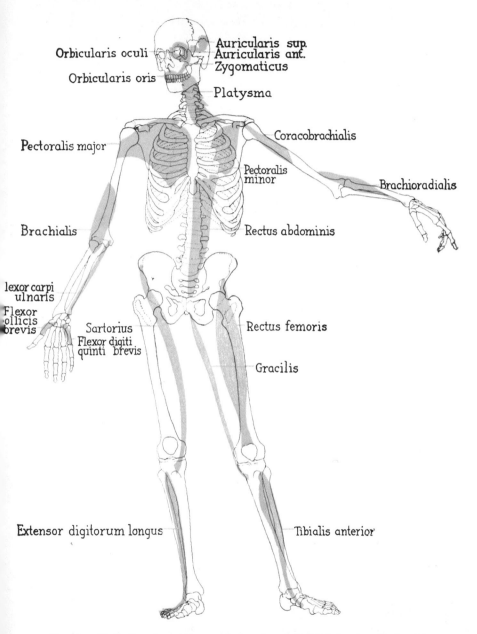

Orbicularis oculi
Orbicularis oris
Auricularis sup.
Auricularis ant.
Zygomaticus
Platysma
Coracobrachialis
Pectoralis major
Pectoralis minor
Brachioradialis
Brachialis
Rectus abdominis
lexor carpi ulnaris
Flexor ollicis brevis
Sartorius
Flexor digiti quinti brevis
Rectus femoris
Gracilis
Extensor digitorum longus
Tibialis anterior

Fig. 69.—Projection of muscles on anterior view of skeleton showing attachments.

MUSCLES SHOWN IN FIG. 70

Muscle	Origin	Insertion	Action
Abductor digiti quinti	Pisiform bone	First phalanx of little finger	Separates the little finger from the ring finger; flexes the first phalanx of little finger
Abductor pollicis brevis	Ridge on multangulum majus (trapezium); and navicular bone	Outer side base first phalanx of thumb	Abducts thumb; flexes the first and extends the second phalanx
Adductor pollicis	Shaft of third metacarpal bone, multangulum majus and minus, and capitate bone	Inner side base of first phalanx	Adduction and opposition of thumb
Adductor longus	Symphysis and crest of pubic bone	Middle third of inner lip of linea aspera	Adducts, flexes, and assists in lateral rotation of thigh
Biceps brachii	Short head from coracoid process; long head from supraglenoidal tuberosity of scapula	Tubercle of radius	Short head adducts arm; long head abducts; flexes and supinates forearm; flexes and rotates arm medially
Deltoideus	Lateral third clavicle; acromion, and inferior edge of spine of scapula	Deltoid tubercle of humerus	Abducts arm; anterior part flexes and rotates arm medially; posterior part extends and rotates arm laterally
Extensor hallucis longus	Middle half of fibula	Terminal phalanx of great toe	Extends great toe; flexes foot
Flexor carpi radialis	Medial epicondyle of humerus	Bases of 2 and usually 3 metacarpal bones	Flexes wrist primarily; assists in abduction of hand
Obliquus externus abdominus	5th to 12th ribs	Anterior two-thirds outer lip of iliac crest. Linea alba, inguinal ligament	Compresses abdomen; draws thorax downward
Obliquus internus abdominus	Outer half of inguinal ligament, anterior half of crest of ilium, lumbar fascia	10th to 12th ribs, 7th to 9th costal cartilages, linea alba of rectus	Compresses abdomen; draws thorax forward; flexes and rotates vertebral column
Pectineus	Crest of pubis	Pectineal line of femur	Flexes and adducts thigh
Peroneus tertius	Distal third of fibula	Base of 5th metatarsal	Assists in dorsal flexion of foot and everts it
Pronator teres	Medial epicondyle of humerus and coronoid process of ulna	Middle third of lateral surface of radius	Pronates forearm; assists in flexion of elbow-joint
Quadratus labii superioris	*Angular head:* frontal process of maxilla (root of nose) *Infraorbital head:* maxilla *Zygomatic head:* zygomatic bone near orbicularis oculi	*Angular head:* alar cartilage of nose and orbicularis oris *Infraorbital head:* orbicularis oris and skin of upper lip *Zygomatic head:* skin of upper lip	Helps in variety of facial expressions
Serratus anterior	Lateral surfaces of upper 8 ribs	Vertebral border of scapula	Draws scapula forward; rotates inferior angle of scapula laterally and forward
Sternocleidomastoideus	Medial third of clavicle and manubrium of sternum	Mastoid process and occipital bone	Rotates head to opposite side; bends head and neck toward shoulder; both sides acting together flex head on chest and extend the head
Vastus lateralis	Lateral lip of linea aspera of femur	Common tendon of quadraceps femoris to tibia	Extends leg at knee; flexes hip-joint; flexes body on hips
Vastus medialis	Medial lip of linea aspera of femur	Common tendon of quadraceps femoris to tibia	Extends leg at knee; flexes hip-joint; flexes body on hips

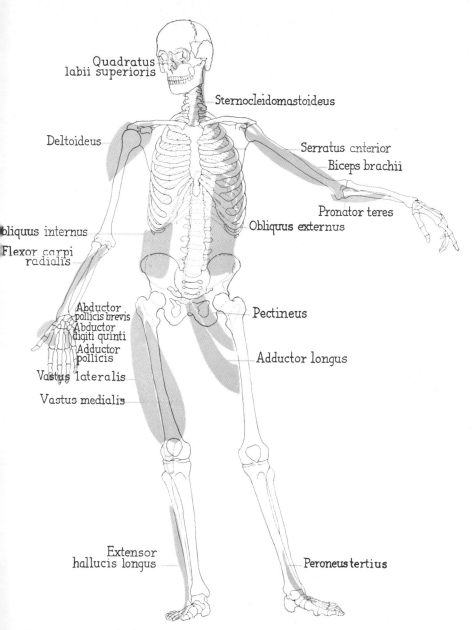

Quadratus labii superioris

Sternocleidomastoideus

Deltoideus

Serratus anterior

Biceps brachii

Pronator teres

Obliquus internus

Obliquus externus

Flexor carpi radialis

Abductor pollicis brevis

Abductor digiti quinti

Adductor pollicis

Pectineus

Adductor longus

Vastus lateralis

Vastus medialis

Extensor hallucis longus

Peroneus tertius

FIG. 70.—Projection of muscles on anterior view of skeleton showing attachments.

MUSCLES SHOWN IN FIG. 71

Muscle	Origin	Insertion	Action
Adductor brevis	Inferior ramus of pubis	Upper third of linea aspera of femur	Assists in adduction, flexion, and lateral rotation of thigh
Adductor magnus	Ischial tuberosity	Linea aspera of femur, tubercle above medial condyle	Adducts thigh; assists in flexion, extension, and lateral rotation
Flexor digitorum sublimis	Medial epicondyle of humerus, coronoid process of ulna, and proximal part of radius	Second phalanges of fingers	Flexes middle phalanges of the fingers, and hand
Iliopsoas	Iliac fossa of ilium, 12th thoracic to 5th lumbar vertebrae	Small trochanter of femur	Flexes thigh; adducts and rotates hip-joint medially
Intercostalis externus	Lower border of each rib	Upper border of next rib	Elevate ribs and aid in respiration
Masseter	Zygomatic arch	Lateral surface of ramus of mandible and coronoid process	Raises mandible and draws it forward
Opponens pollicis	Great multangular bone and transverse carpal ligament	Metacarpal of thumb	Simultaneously draws first metacarpal bone medially and forwards
Palmaris longus	Medial epicondyle of humerus	Fascia of palm	Flexes the wrist; tenses the fascia of palm
Transversus abdominis	Lower six costal cartilages; lumbodorsal fascia; anterior two-thirds internal lip of iliac crest; lateral third of inguinal ligament	Xiphoid process; linea alba; pubic tubercle	Compresses abdomen

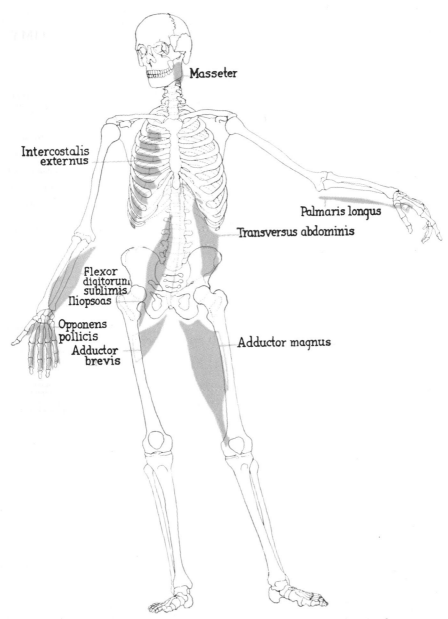

Masseter

Intercostalis externus

Palmaris longus

Transversus abdominis

Flexor digitorum sublimis

Iliopsoas

Opponens pollicis

Adductor brevis

Adductor magnus

FIG. 71.—Projection of muscles on anterior view of skeleton showing attachments.

MUSCLES SHOWN IN FIG. 72

MUSCLE	ORIGIN	INSERTION	ACTION
Biceps femoris	Long head from ischial tuberosity; short head from middle third of linea aspera	Lateral condyle of tibia; head of fibula	Flexes knee-joint; extends thigh; rotates leg laterally when knee is flexed
Extensor carpi ulnaris	Lateral epicondyle of humerus; proximal part of ulna	Base of fifth metacarpal	Extensor and adductor of the wrist, and fifth finger
Extensor digitorum communis	Lateral epicondyle of humerus	By four tendons into phalanges of fingers	Extends fingers and wrist
Extensor digiti quinti proprius	Lateral epicondyle of humerus	First phalanx of little finger	Extends little finger (and wrist)
Gastrocnemius	Medial and lateral condyles of femur	Calcaneus, through tendon of Achilles	Flexes knee; extends adducts and inverts foot
Gluteus maximus	Ilium, sacrum, coccyx, sacrotuberous ligament	Iliotibial tract and gluteal tuberosity of femur	Extends thigh, adducts thigh and rotates it laterally
Latissimus dorsi	Spines of lower 6 thoracic vertebrae, lumbodorsal fascia, crest of ilium, upper lumbar vertebrae, lower 3 or 4 ribs, inferior angle of scapula	Intertubercular sulcus of humerus	Adducts, extends and rotates arm medially
Plantaris	Lateral epicondylic line of femur	Inner margin of tendon of Achilles (calcaneus tendon)	Flexes leg and extends foot
Soleus	Middle third of tibia, head and proximal third of fibula	Calcaneus, through tendon of Achilles	Extends, adducts and inverts foot
Splenius capitis	Nuchal ligament, upper three thoracic vertebrae	Mastoid process of temporal bone and occipital bone	Rotates head; together draw head backwards
Trapezius	Occipital bone, nuchal ligament, seventh cervical and all thoracic vertebrae	Lateral third of clavicle, acromion, and lateral part of spine of scapula	Rotates inferior angle of scapula laterally and forwards; elevates lateral end of clavicle, of scapula; approximates the scapulae; extends the head
Triceps brachii	Long head, from infraglenoid tuberosity. Medial and lateral head, from posterior surface of humerus	Olecranon of ulna	Extends forearm, long head adducts the arm at shoulder-joint

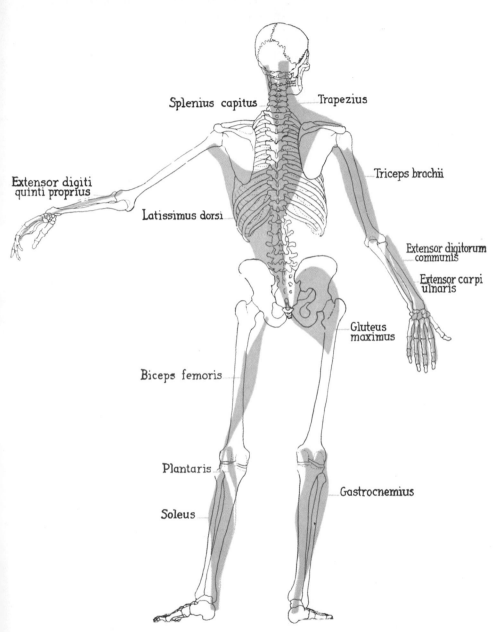

Splenius capitus

Trapezius

Triceps brachii

Extensor digiti
quinti proprius

Latissimus dorsi

Extensor digitorum
communis

Extensor carpi
ulnaris

Gluteus
maximus

Biceps femoris

Plantaris

Gastrocnemius

Soleus

Fɪɢ. 72.—Projection of muscles on posterior view of skeleton showing **attachments**.

MUSCLES SHOWN IN FIG. 73

Muscle	Origin	Insertion	Action
Extensor carpi radialis brevis	Lateral epicondyle of humerus	2nd and 3rd metacarpals	Extends hand and abducts wrist
Extensor carpi radialis longus	Lateral epicondylic ridge of humerus	Second metacarpal	Extends and abducts hand; flexes forearm
Flexor digitorum longus	Middle three-fifths dorsal surface of tibia	Phalanges of four lateral toes	Flexes digits; extends and inverts foot
Gluteus medius	Lateral surface of ilium	Great trochanter of femur	Abducts thigh; medial rotator of thigh
Gluteus minimus	Lateral surface of ilium	Great trochanter of ilium	Abducts thigh; medial or lateral rotator of extended limb
Infraspinatus	Infraspinous fossa of scapula	Greater tubercle of humerus	Rotates arm laterally
Levator scapulae	First three or four cervical vertebrae	Vertebral border of scapula between medial angle and root of spine	Rotates inferior angle of scapula medially; elevates shoulder
Popliteus	Lateral condyle of femur	Proximal fifth of tibia	Flexes knee; rotates leg medially
Rhomboideus major	Upper 2, 3, 4, 5th thoracic vertebrae	Vertebral border of scapula	Rotates inferior angle of scapula medially; elevates shoulder; approximates the two scapulae
Rhomboideus minor	Nuchal ligament, 7th cervical and first thoracic vertebrae	Vertebral border of scapula	Rotates inferior angle of scapula medially; elevates shoulder; approximates the two scapulae
Sacrospinalis	Dorsal surface of sacrum, spines of lumbar vertebrae, crest of ilium; divides into several groups of muscles	Lumbar, thoracic, cervical vertebrae; ribs; and mastoid process	Extends vertebral column and head; bends vertebral column and head to side; numerous complex actions of vertebral column
Semimembranosus	Ischial tuberosity	Medial condyle of tibia	Flexes leg and rotates it medially; extends and adducts thigh; rotates it medially
Semitendinosus	Ischial tuberosity	Medial surface of tibia	Flexes knee and rotates it medially; extends and adducts thigh; rotates it medially
Supraspinatus	Supraspinous fossa of scapula	Greater tubercle of humerus	Assists in abduction of arm
Teres major	Axillary border of scapula	Intertubercular sulcus of humerus	Adducts, extends and rotates arm medially
Teres minor	Axillary border of scapula	Greater tubercle of humerus	Adductor and lateral rotator of arm
Tibialis posterior	Posterior surface of tibia, fibula, and interosseous membrane	Navicular, cuboid, all cuneiform bones, second to fourth metatarsals	Adducts, extends and inverts foot; (assists in the maintenance of arch of foot)

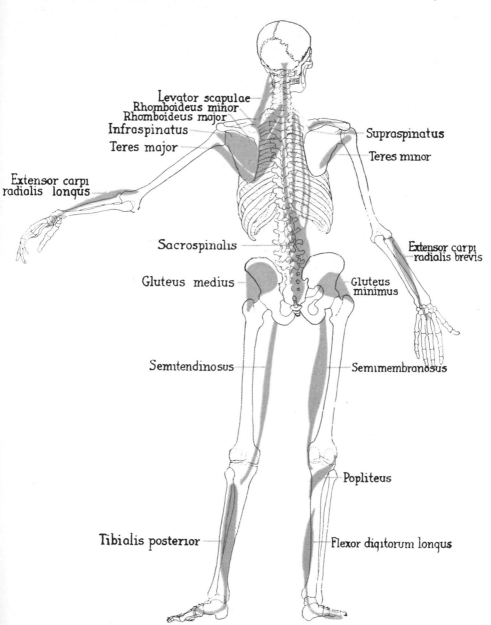

Levator scapulae
Rhomboideus minor
Rhomboideus major
Infraspinatus
Teres major

Supraspinatus

Teres minor

Extensor carpi
radialis longus

Sacrospinalis

Gluteus medius

Extensor carpi
radialis brevis

Gluteus
minimus

Semitendinosus

Semimembranosus

Popliteus

Tibialis posterior

Flexor digitorum longus

FIG. 73.—Projection of muscles on posterior view of skeleton showing attachments.

MUSCLES SHOWN IN FIG. 74

MUSCLE	ORIGIN	INSERTION	ACTION
Abductor pollicis longus	Dorsal surface of ulna, radius, and interosseous membrane	Base of first metacarpal	Abducts and extends thumb Muscles Shown in Fig. 74
Anconeus	Lateral epicondyle of humerus	Olecranon of ulna	Extends forearm
Deltoideus	Lateral third clavicle; acromion, and inferior edge of spine of scapula	Deltoid tubercle of humerus	Abducts arm; anterior part flexes and rotates arm medially; posterior part extends and rotates arm laterally
Flexor hallucis longus	Distal two-thirds of fibula	Terminal phalanx of great toe	Flexes great toe; extends and inverts foot
Peroneus longus	Head and body of fibula, lateral condyle of tibia	By tendon passing behind lateral malleolus and across sole of foot to first cuneiform and first metatarsal	Supports transverse arch of foot; extends, abducts, and everts foot
Rectus abdominis	Symphysis and crest of pubis	Xiphoid process and 5-7 ribs	Draws thorax downward; flexes vertebral column and pelvis, supports abdominal viscera
Temporalis	Temporal fossa of temporal bone	Coronoid process of mandible	Raises mandible
Tensor fasciae latae	Anterior superior spine and anterior part iliac crest	Iliotibial tract	Tenses fascia lata; abducts and rotates thigh medially
Trapezius	Occipital bone, nuchal ligament, seventh cervical and all thoracic vertebrae	Lateral third of clavicle, acromion and lateral part of spine of scapula	Rotates inferior angle of scapula laterally and forwards; elevates lateral end of clavicle, of scapula; approximates the scapulae; extends the head

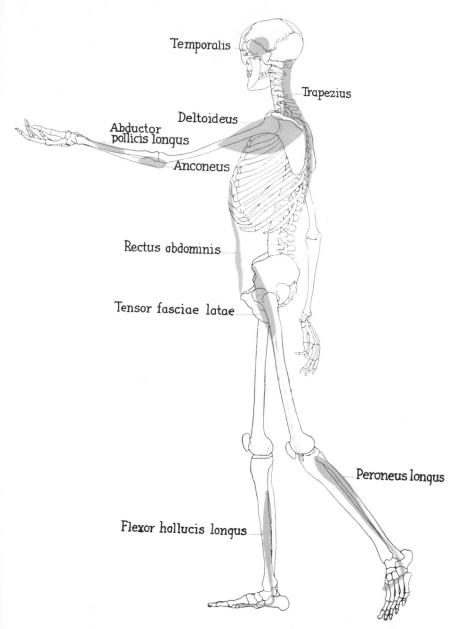

Temporalis

Trapezius

Deltoideus

Abductor
pollicis longus

Anconeus

Rectus abdominis

Tensor fasciae latae

Peroneus longus

Flexor hallucis longus

FIG. 74.—Projection of muscles on lateral surface of skeleton showing attachments.

CHAPTER VII

MUSCLES OF THE HEAD AND NECK

Muscle	Origin	Insertion	Action
Auricularis anterior	Temporal fascia	Cartilage of ear	Draws ear forward
Auricularis superior	Epicranial aponeurosis	Cartilage of ear	Draws ear upward
Buccinator	Maxilla, mandible	Orbicularis oris muscle	Retracts angle of mouth and flattens lips and cheek against teeth
Caninus	Canine fossa of maxilla	Orbicularis oris muscle and skin	Raises angle of mouth
Corrugator	Frontal bone	Skin of eyebrow	Draws inner angle of eyebrow downward and wrinkles forehead
Epicranius			
Frontalis	Epicranial aponeurosis	Skin of eyebrow. Root of nose	Elevates eyebrow, wrinkles forehead
Occipitalis	Superior nuchal line of occipital bone	Epicranial aponeurosis	Draws scalp backward, and tenses epicranial aponeurosis
Incisivus labii inferior and superior (not visible)	Maxilla and mandible	Orbicularis oris muscle	Draws corners of lips medially
Masseter	Zygomatic arch	Lateral surface of ramus of mandible and coronoid process	Raises mandible and draws it forward
Mentalis	Mandible, below the lateral incisor tooth	Skin of chin	Draws up skin of chin
Nasalis	Maxilla and dorsum of nose	Margin of nostril and skin of nasolabial groove	Constricts nostrils; draws wings of nose laterally and upward
Orbicularis oculi	Maxilla, frontal bone, and medial palpebral ligament	There is no bony insertion The muscle fibres form a complete ellipse and terminate at the origin	Closes eye; draws eyelid towards median line; stretches skin of forehead
Orbicularis oris	Various muscles converging into the mouth	No bony insertion. Skin of lips	Draws lips together; helps in infinite variety of facial expressions as joy, grief, despair, etc.
Platysma	Fascia covering pectoralis major and deltoid muscles	Inferior border of mandible; risorius muscle in corner of mouth	Depresses angle of mouth; wrinkles skin of neck in oblique direction across lower jaw
Procerus	Membrane of bridge of nose	Skin over root of nose	Draws skin of forehead down
Quadratus labii inferioris	Mandible below canine and premolar teeth	Lower lip	Draws lower lip downward
Quadratus labii superioris	*Angular head:* frontal process of maxilla (root of nose) *Infraorbital head:* maxilla *Zygomatic head:* zygomatic bone near orbicularis oculi	*Angular head:* alar cartilage of nose and orbicularis oris *Infraorbital head:* orbicularis oris and skin upper lip *Zygomatic head:* skin of upper lip	Helps in variety of facial expressions
Risorius	Continuation of platysma, subcutaneous tissue over parotid gland	Skin and mucous membrane at corner of mouth	Draws corner of mouth laterally
Triangularis	Mandible below canine, premolar and first molar teeth	Orbicularis oris muscle and skin	Draws corner of mouth downward
Zygomaticus	Zygomatic bone	Partly in skin about angle of mouth; partly into the orbicularis oris	Draws upper lip upward as in laughing; aids in other facial expressions

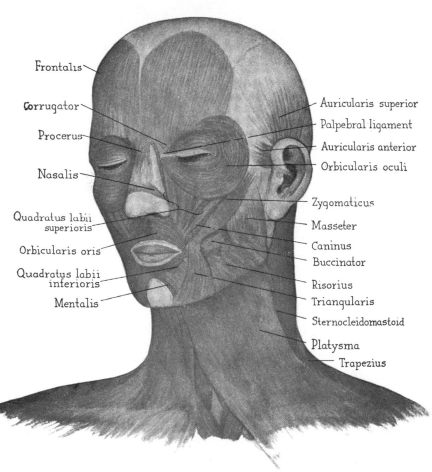

Frontalis

Corrugator

Procerus

Nasalis

Quadratus labii
superioris

Orbicularis oris

Quadratus labii
inferioris

Mentalis

Auricularis superior

Palpebral ligament

Auricularis anterior

Orbicularis oculi

Zygomaticus

Masseter

Caninus

Buccinator

Risorius

Triangularis

Sternocleidomastoid

Platysma

Trapezius

FIG. 75.—Muscles of the face and head, viewed from the left.

THE ANATOMY OF THE SMILE

The famous "Mona Lisa Gioconda" of Leonardo da Vinci illustrates an expression of elusiveness—with a delightful smile exceedingly difficult to analyze.

The following changes are evident in the smiling face:

1. The face becomes broader.

2. The upper lip and corner of the mouth are retracted upward and lateralward by the action of the zygomaticus and the quadratus labii superioris.

3. The contraction of the above mentioned muscles causes a smooth roundness under the eye, which results in a furrow under the eye.

4. The naso-labial groove becomes shallower and broader.

5. There is practically no action of the frontalis or corrugator muscles on the forehead.

From an anatomical point of view, the above mentioned facts create a smile. Yet, what would this masterpiece be without Leonardo's power of expression—his Art telling a story, or hundreds of stories through Mona Lisa's famous eyes?

FIG. 76.—"Mona Lisa."

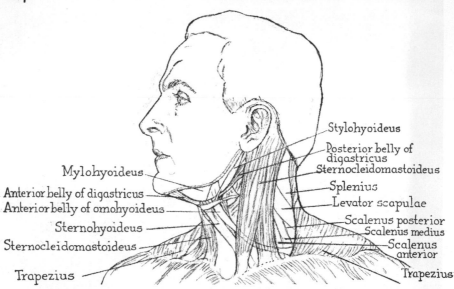

Stylohyoideus
Posterior belly of
digastricus
Sternocleidomastoideus
Splenius
Levator scapulae
Scalenus posterior
Scalenus medius
Scalenus
anterior
Trapezius

Mylohyoideus
Anterior belly of digastricus
Anterior belly of omohyoideus
Sternohyoideus
Sternocleidomastoideus
Trapezius

Fig. 77.—Labeled sketch of the muscles of the neck.

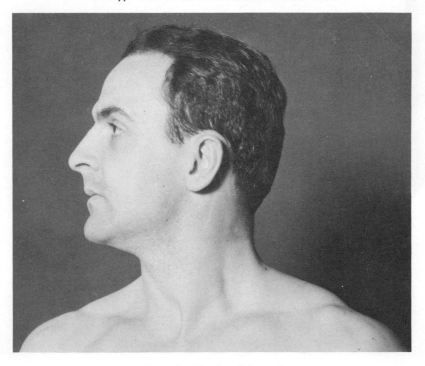

Fig. 78.—Muscles of the neck.

CHAPTER VIII

MUSCULAR LANDMARKS OF THE
HUMAN FIGURE

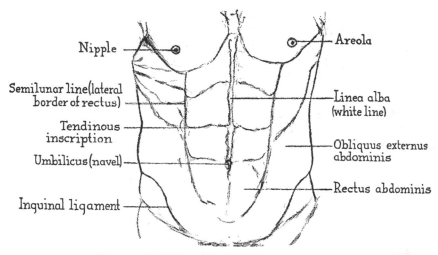

FIG. 79.—Labeled sketch of the abdominal muscles.

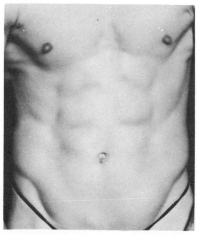

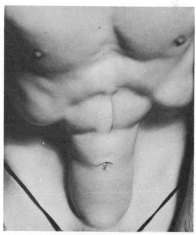

FIG. 80.—The abdominal muscles slightly contracted.

FIG. 81.—The abdominal muscles fully contracted.

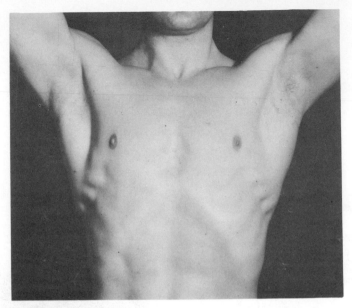

Fig. 82.—Axilla and shoulder, anterior view, arms overhead.

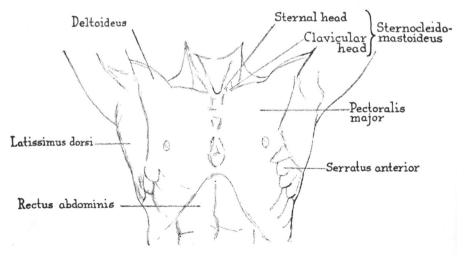

Fig. 83.—Labeled sketch of muscles shown in Fig. 82.

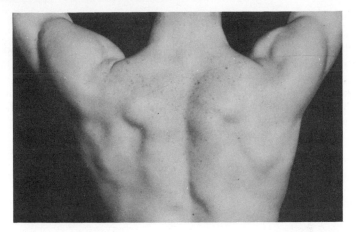

FIG. 84.—Shoulder and scapular region, posterior view, arms overhead.

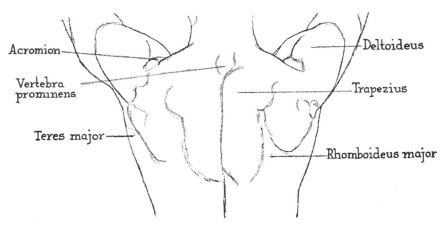

Acromion

Vertebra
prominens

Teres major

Deltoideus

Trapezius

Rhomboideus major

FIG. 85.—Labeled sketch of muscles shown in Fig. 84.

AXILLA AND SHOULDER FROM THE FRONT

The axilla is the hollow or armpit between the proximal part of the arm and the side of the thorax. The axilla is bounded in front by the two pectoral muscles, the major forming a beautiful border in figure 86; while behind, the latissimus dorsi, teres major and subscapularis form the thick rounded margin. The lateral or outer boundary is formed by the biceps brachii and the coraco-brachialis. The inner wall is formed by the distinct digitations of the serratus anterior and their ribs.

SHOULDER AND SCAPULAR REGION FROM BEHIND

The bony points visible in Fig. 87 are: (1) the spine of the scapula, (2) the acromion process of the scapula, (3) the prominent seventh cervical vertebra, and (4) the inferior angle of the scapula.

The prominent muscular elevations are (1) trapezius, (2) deltoideus, (3) latissimus dorsi, (4) rhomboideus major.

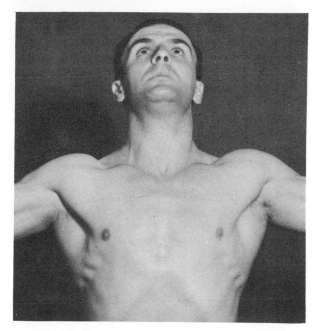

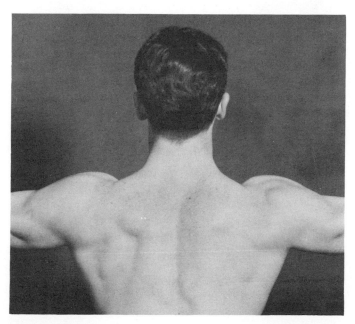

FIG. 87.—Shoulder and scapular region, arms abducted about 90°.

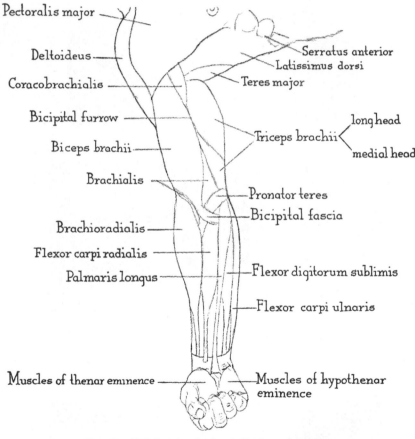

Pectoralis major

Deltoideus

Coracobrachialis

Bicipital furrow

Biceps brachii

Brachialis

Brachioradialis

Flexor carpi radialis

Palmaris longus

Muscles of thenar eminence

Serratus anterior

Latissimus dorsi

Teres major

long head

Triceps brachii

medial head

Pronator teres

Bicipital fascia

Flexor digitorum sublimis

Flexor carpi ulnaris

Muscles of hypothenar eminence

FIG. 88.—Labeled sketch of muscles shown in Fig. 89.

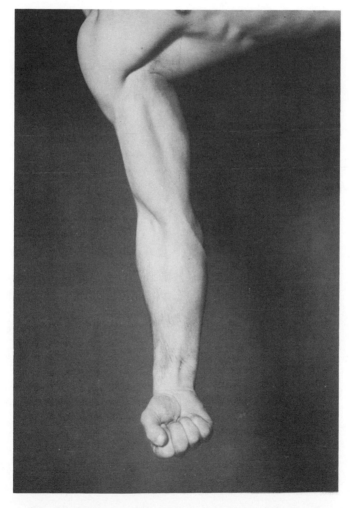

FIG. 89.—The upper right extremity abducted and supinated.

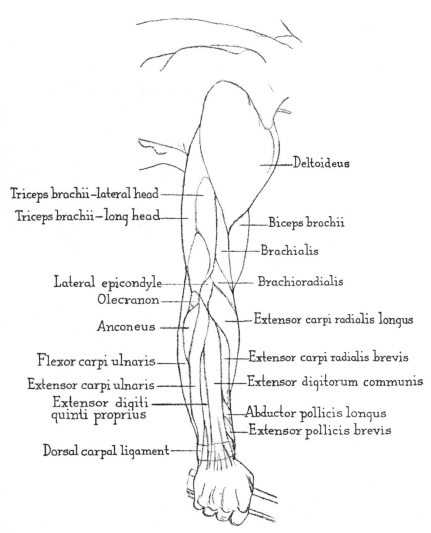

Deltoideus

Triceps brachii–lateral head

Triceps brachii–long head

Biceps brachii

Brachialis

Lateral epicondyle

Olecranon

Brachioradialis

Anconeus

Extensor carpi radialis longus

Flexor carpi ulnaris

Extensor carpi radialis brevis

Extensor carpi ulnaris

Extensor digitorum communis

Extensor digiti
quinti proprius

Abductor pollicis longus

Extensor pollicis brevis

Dorsal carpal ligament

FIG. 90.—Labeled sketch of the upper right extremity, posterior view.

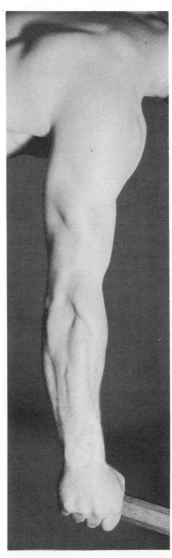

FIG. 91.—The upper right extremity, posterior view.

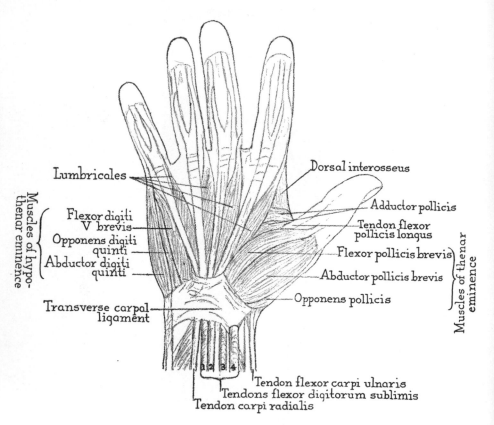

Lumbricales

Dorsal interosseus

Adductor pollicis

Muscles of hypo-thenar eminence

Flexor digiti
V brevis

Opponens digiti
quinti

Abductor digiti
quinti

Tendon flexor
pollicis longus

Flexor pollicis brevis

Abductor pollicis brevis

Muscles of thenar eminence

Transverse carpal
ligament

Opponens pollicis

1 2 3 4

Tendon flexor carpi ulnaris
Tendons flexor digitorum sublimis
Tendon carpi radialis

FIG. 92.—Labeled sketch of the palmar view of the hand.

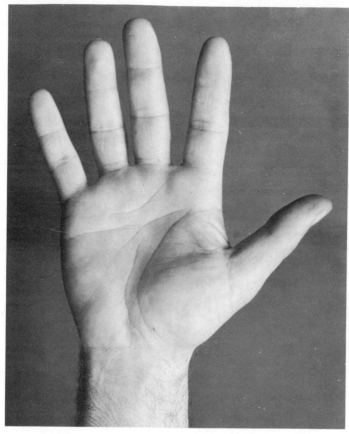

FIG. 93.—The hand, palmar view. (See page 149 for other details regarding the hand.)

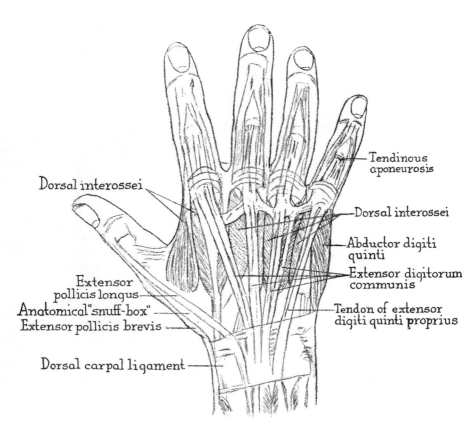

Dorsal interossei

Tendinous
aponeurosis

Dorsal interossei

Abductor digiti
quinti

Extensor digitorum
communis

Extensor
pollicis longus
Anatomical "snuff-box"
Extensor pollicis brevis

Tendon of extensor
digiti quinti proprius

Dorsal carpal ligament

FIG. 94.—Labeled sketch of the posterior view of the hand.

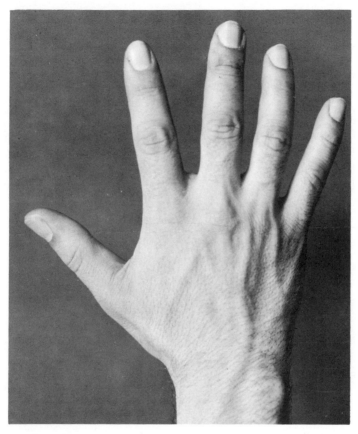

FIG. 95.—The hand, posterior view, the superficial veins are quite visible.

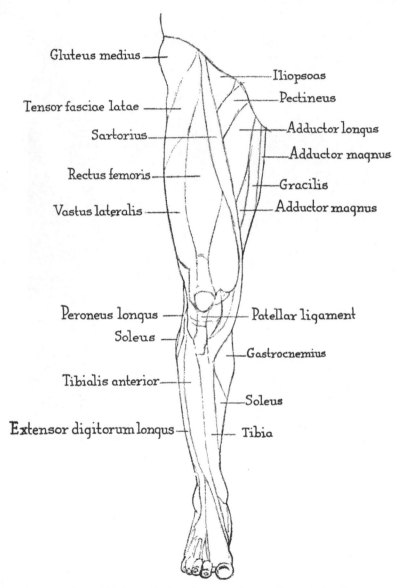

Gluteus medius

Tensor fasciae latae

Sartorius

Rectus femoris

Vastus lateralis

Iliopsoas

Pectineus

Adductor longus

Adductor magnus

Gracilis

Adductor magnus

Peroneus longus

Soleus

Tibialis anterior

Extensor digitorum longus

Patellar ligament

Gastrocnemius

Soleus

Tibia

FIG. 96.—Labeled sketch of the lower right extremity, anterior view.

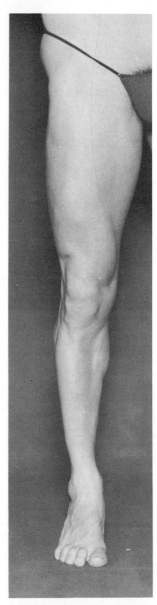

FIG. 97.—The lower right extremity, anterior view.

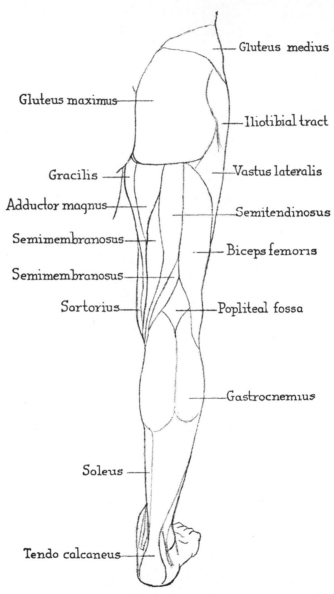

Gluteus medius

Gluteus maximus

Iliotibial tract

Gracilis

Vastus lateralis

Adductor magnus

Semitendinosus

Semimembranosus

Biceps femoris

Semimembranosus

Sartorius

Popliteal fossa

Gastrocnemius

Soleus

Tendo calcaneus

FIG. 98.—Labeled sketch of the lower right extremity, posterior view.

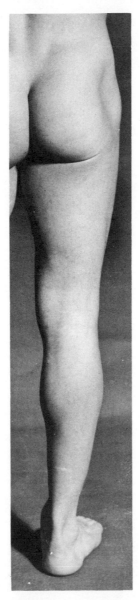

FIG. 99.—The lower right extremity, posterior view.

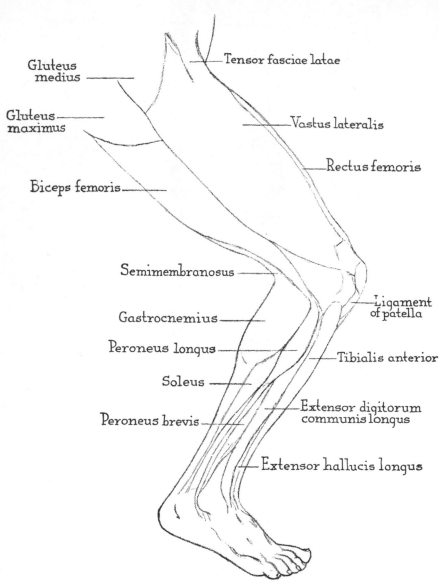

Gluteus medius

Gluteus maximus

Biceps femoris

Tensor fasciae latae

Vastus lateralis

Rectus femoris

Semimembranosus

Gastrocnemius

Peroneus longus

Soleus

Peroneus brevis

Ligament of patella

Tibialis anterior

Extensor digitorum communis longus

Extensor hallucis longus

FIG. 100.—Labeled sketch of the lower right extremity shown in Fig. 101.

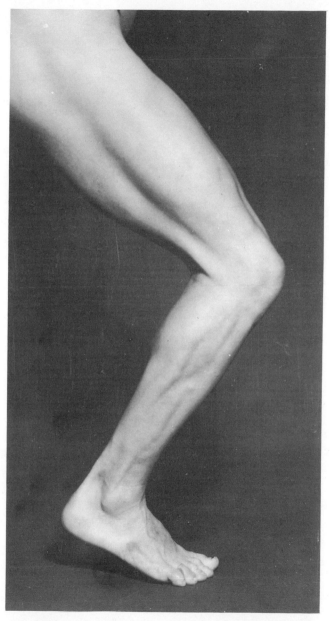

FIG. 101.—The lower right extremity partly flexed, lateral external view.

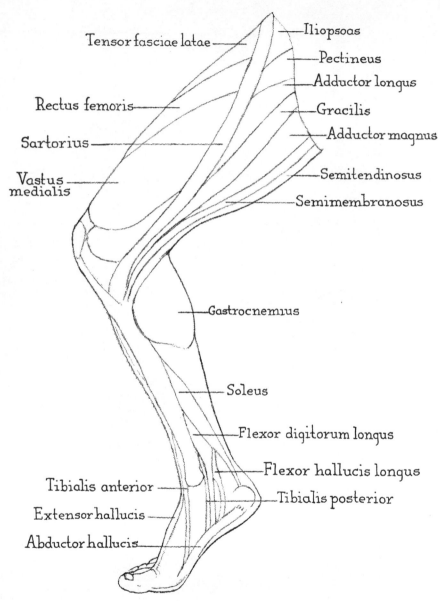

Tensor fasciae latae

Rectus femoris

Sartorius

Vastus medialis

Iliopsoas

Pectineus

Adductor longus

Gracilis

Adductor magnus

Semitendinosus

Semimembranosus

Gastrocnemius

Soleus

Flexor digitorum longus

Flexor hallucis longus

Tibialis posterior

Tibialis anterior

Extensor hallucis

Abductor hallucis

FIG. 102.—Labeled sketch of the lower right extremity shown in Fig. 103.

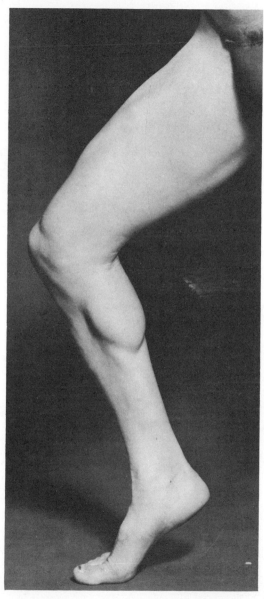

FIG. 103.—The lower right extremity partly bent, internal view.

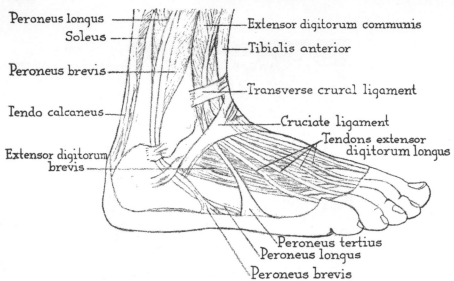

FIG. 104.—Labeled sketch of the right foot, external lateral view.

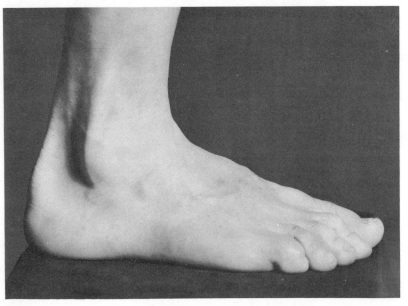

FIG. 105.—The right foot, external lateral view.

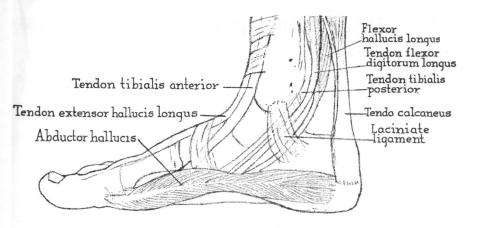

Tendon tibialis anterior

Tendon extensor hallucis longus

Abductor hallucis

Flexor hallucis longus

Tendon flexor digitorum longus

Tendon tibialis posterior

Tendo calcaneus

Laciniate ligament

FIG. 106.—Labeled sketch of the right foot, internal view.

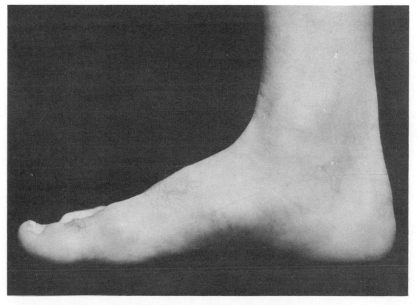

FIG. 107.—The right foot, internal view.

FIG. 108.—Demonstration of sartorius muscle.

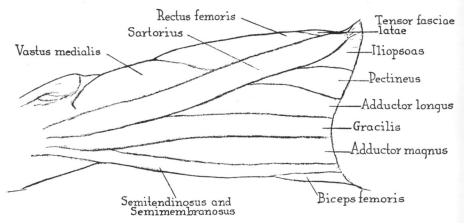

FIG. 109.—Labeled sketch of the sartorius muscle.

CHAPTER IX
MUSCLES GROUPED ACCORDING TO THEIR PRINCIPAL ACTION

Muscles of the Head.

MUSCLES AFFECTING THE ORAL ORIFICE.
Retractors downward: platysma, triangularis, and quadratus labii inferioris.
Retractors upward: quadratus labii superioris, zygomaticus, caninus.
Retractors lateralward: zygomaticus, platysma, risorius, triangularis, buccinator.
Contractors: orbicularis oris (incisivis labii superioris and inf.).

MUSCLES AFFECTING THE ORBIT.
Retractors: epicranius, levator palpebrae (raises eyelid).
Contractors: orbicularis oculi, procerus, corrugator.

MUSCLES AFFECTING THE NASAL ORIFICE.
Dilators: quadratus labii superioris (angular head), nasalis (transverse head).
Contractors: nasalis (alar portion), depressor septi nasi.

MUSCLES AFFECTING THE EAR.
Retractors: auricularis anterior, superior, and posterior.

MUSCLES ACTING IN MASTICATION (chewing).
Masseter, temporalis, pterygoideus externus and internus.

Muscles acting on the Head.
Sternocleidomastoideus, trapezius, splenius capitis, supra- and infrahyoids.

Muscles acting on the Spine.
Sternocleidomastoideus, psoas major, rectus abdominis, obliquus externus and internus, sacrospinalis, levator scapulae, and splenius capitis.

Muscles acting on the Shoulder-girdle.
Elevation: levator scapulae, trapezius, rhomboideus major and minor.
Depression: pectoralis minor, latissimus dorsi, subclavius, lower parts of trapezius and pectoralis major.
Abduction: pectoralis major and minor, serratus anterior.
Adduction: latissimus dorsi, rhomboideus major and minor, trapezius.

Muscles acting on the Arm at the Shoulder-joint.
Abduction: supraspinatus, deltoideus.
Adduction: latissimus dorsi, teres major, pectoralis major, coraco-brachialis.
Inward rotation: subscapularis.
Outward rotation: teres minor, infraspinatus.

Flexion: pectoralis major, clavicular part of deltoideus, coraco-brachialis, serratus anterior, short head of biceps.

Extension: latissimus dorsi, teres major, posterior part of deltoideus.

Muscles acting on the Forearm.

Flexion: brachioradialis, biceps brachii, brachialis.

Extension: triceps, and anconeus.

Pronation: pronator teres, pronator quadratus.

Supination: supinator.

Muscles acting on the Hand at the Wrist.

Flexion: flexor carpi radialis, flexor carpi ulnaris, palmaris longus.

Extension: extensor carpi radialis longus and brevis, extensor carpi ulnaris.

Muscles acting on the Pelvis.

Flexion: rectus abdominis, obliquus externus and internus, psoas major.

Extension: sacrospinalis.

Lateral flexion: rectus abdominis, obliquus externus and internus.

Muscles acting on the Thigh at the Hip-joint.

Flexion: iliopsoas.

Extension: gluteus maximus.

Adduction: gracilis, pectineus, adductors brevis, longus, and magnus.

Abduction: gluteus medius and minimus, tensor fasciae latae.

Inward rotation: gluteus medius and minimus, tensor fasciae latae.

Outward rotation: quadratus femoris, pyriformis, gemelli, obturators.

Muscles acting on the Leg at the Knee-joint.

Flexion: sartorius, semitendinosus, semimembranosus, biceps, popliteus.

Extension: quadriceps femoris composed of the following four muscles: rectus femoris, vastus lateralis, vastus medialis, and vastus intermedius.

Muscles acting on the Foot at the Ankle-joint.

Flexion: tibialis anterior.

Extension: gastrocnemius, plantaris, soleus.

CHAPTER X

SKIN, FASCIAE, AND FAT

The skin or integument covers the whole body. It serves as an organ of protection, and assists in regulating body temperature. The colour of this elastic tissue is due chiefly to pigment, and partly to the blood. The skin is yellowish in old age, and pinkish in childhood. The hair and nails are both derivatives of the skin.

The surface of the body presents lines and ridges well marked on the palm of the hand and the sole of the foot. The coarser and more conspicuous rather thick lines are flexure lines, while the finer markings are the papillary ridges, as illustrated in figure 145. The palmist examines the flexure lines in the exercise of his calling, while the criminologist is able to detect, register and identify individuals by the papillary ridge pattern. A flexure line marks the site of "a skin joint," a folding point of the skin and subcutaneous tissue.

Beneath the skin there are two layers of tissue that are in close relation to the muscular system: (1) the superficial fascia, with its fat, and (2) the deep fascia.

The **superficial fascia** covers the entire body immediately under the skin. It is impregnated usually with fat, more especially in the regions indicated in Figs. 112, 116, 120. **Fat** reduces the irregularities of the underlying bones and muscles, especially in the female, to form smooth, round, graceful curves. If the model is well nourished examination of the surface does not reveal much information, for the entire superficial fascia is well loaded with fat, which obscures the prominences and bulging made by bones, muscles and tendons, rendering their identification difficult even under digital examination.

The **deep fascia** lies underneath the skin and superficial fascia. It is a bluish white membrane, devoid of fat, which covers and invests the muscles, ligaments, and parts of the skeleton. It is attached to all subcutaneous bony prominences.

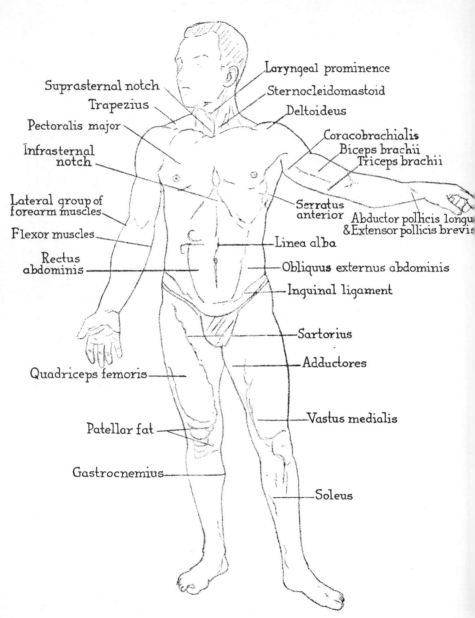

Laryngeal prominence
Sternocleidomastoid
Deltoideus
Coracobrachialis
Biceps brachii
Triceps brachii

Suprasternal notch
Trapezius
Pectoralis major
Infrasternal
notch

Lateral group of
forearm muscles
Flexor muscles
Rectus
abdominis

Serratus
anterior Abductor pollicis longu
&Extensor pollicis brevi

Linea alba
Obliquus externus abdominis
Inguinal ligament

Sartorius

Adductores

Quadriceps femoris

Vastus medialis

Patellar fat

Gastrocnemius

Soleus

Fig. 110.—Key to muscular projections, anterior view.

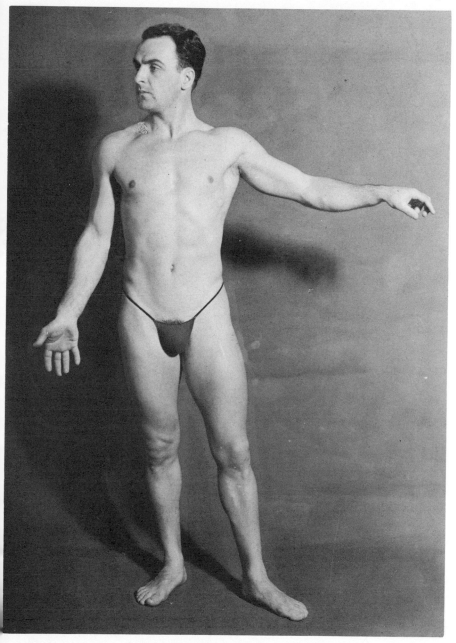

FIG. III.—Male figure, anterior view.

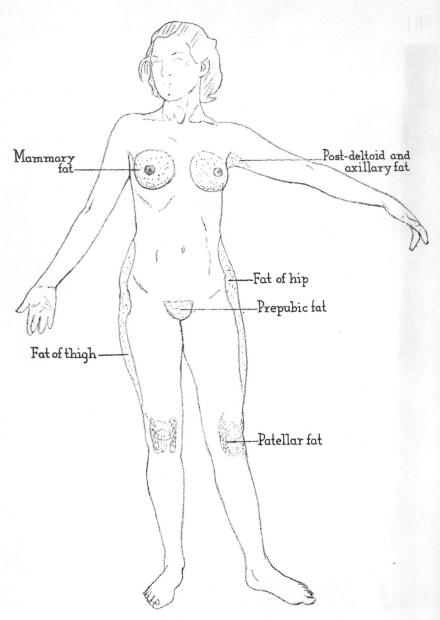

FIG. 112.—Fat distribution on female figure, anterior view.

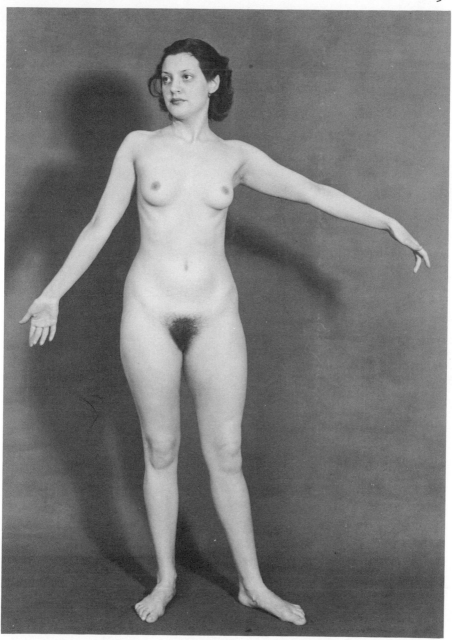

FIG. 113.—Female figure, anterior view.

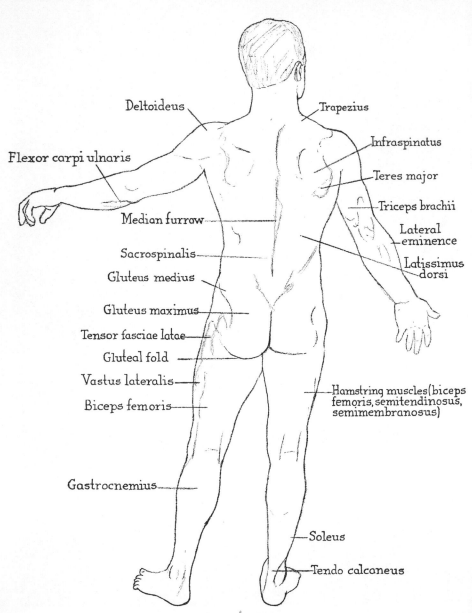

Deltoideus

Trapezius

Infraspinatus

Flexor carpi ulnaris

Teres major

Triceps brachii

Median furrow

Lateral eminence

Sacrospinalis

Latissimus dorsi

Gluteus medius

Gluteus maximus

Tensor fasciae latae

Gluteal fold

Vastus lateralis

Hamstring muscles(biceps femoris, semitendinosus, semimembranosus)

Biceps femoris

Gastrocnemius

Soleus

Tendo calcaneus

FIG. 114.—Key to muscular projections, posterior view.

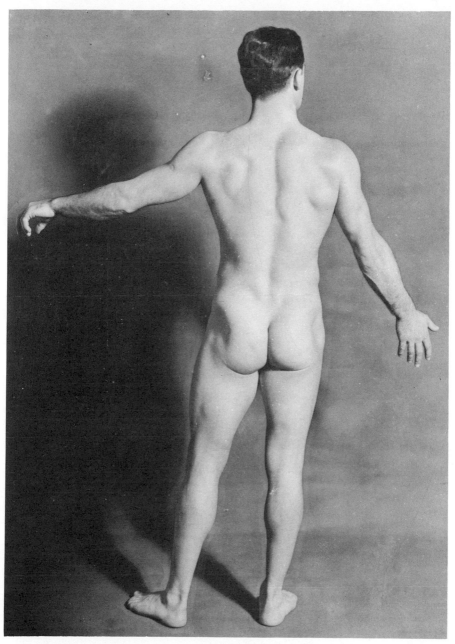

FIG. 115.—Male figure, posterior view.

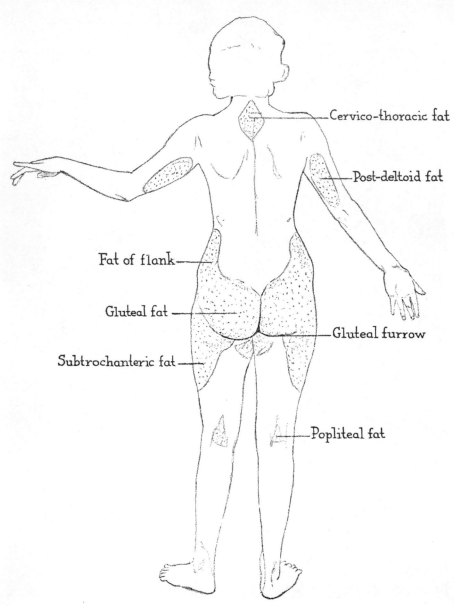

FIG. 116.—Fat distribution on female figure, posterior view.

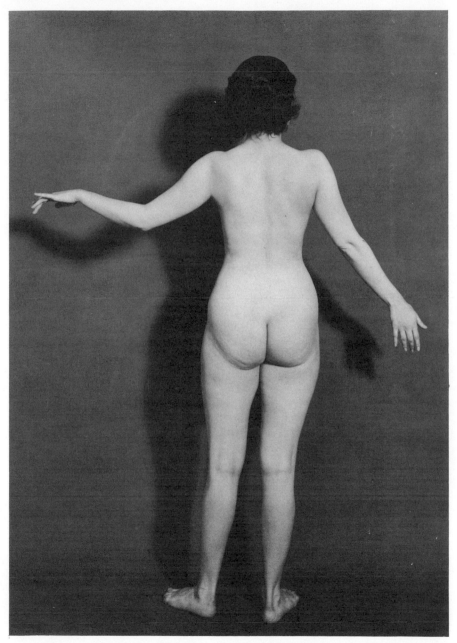

FIG. 117.—Female figure, posterior view.

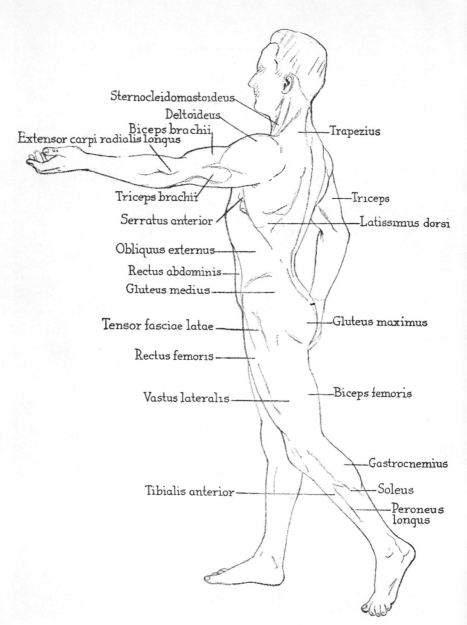

Sternocleidomastoideus
Deltoideus
Biceps brachii
Extensor carpi radialis longus

Trapezius

Triceps brachii

Triceps

Serratus anterior

Latissimus dorsi

Obliquus externus
Rectus abdominis
Gluteus medius

Tensor fasciae latae

Gluteus maximus

Rectus femoris

Vastus lateralis

Biceps femoris

Gastrocnemius

Tibialis anterior

Soleus

Peroneus
longus

FIG. 118.—Key to muscular projections, left side view.

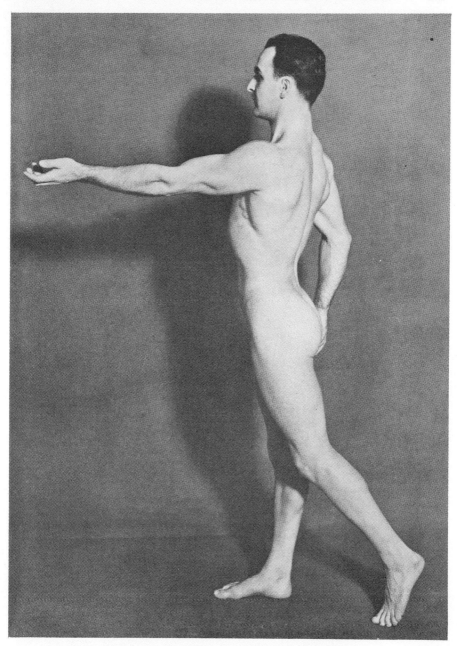

FIG. 119.—Male figure, viewed from the left side.

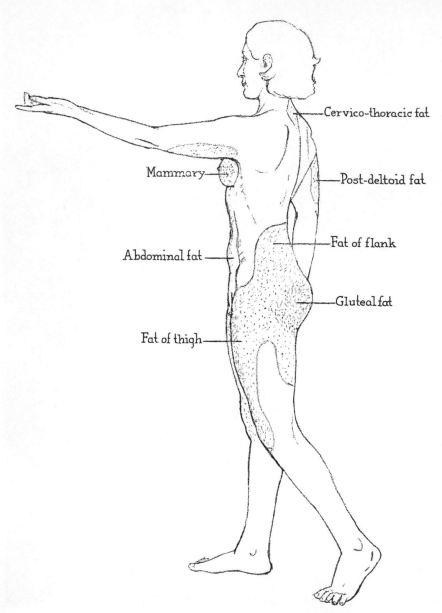

Cervico-thoracic fat

Mammary

Post-deltoid fat

Abdominal fat

Fat of flank

Gluteal fat

Fat of thigh

FIG. 120.—Fat distribution on female figure, lateral view.

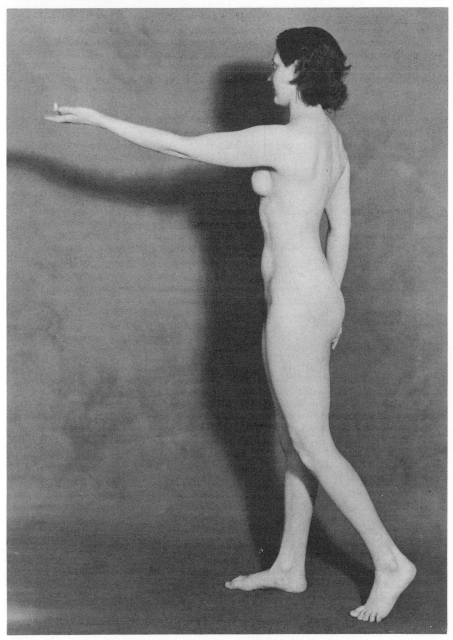

FIG. 121.—Female figure, viewed from the left side.

CHAPTER XI

SURFACE ANATOMY OF THE CHILD

The child of nine years of age measures about six head-lengths.

In Fig. 122, observe the following structures, and compare with Fig. 111 of the adult male:

> Sternocleidomastoids.
> Latissimus dorsi.
> Rectus abdominis.
> Biceps brachii.
> Deltoideus.
> Rib cage outline.
> Inguinal (Poupart's) ligament.
> **Waist** lacking in child.

In Fig. 123, observe the following structures, and compare with Fig. 115 of the adult male:

> Trapezius.
> Latissimus dorsi.
> Deltoideus.
> Triceps.
> Median furrow of back.
> Vertebral border of scapula.
> Gluteal fold.
> Medial epicondyle of femur.
> Vertebral column curve to right to coun-
> ter-balance weight of abducted left arm.

In Fig. 124, observe the following structures, and compare with Fig. 119 of the adult male:

> Deltoideus.
> Latissimus dorsi.
> Biceps brachii.
> Median spinal furrow.
> Vertebral column curvatures.
> Rib outline.
> Lateral malleolus of fibula.

124

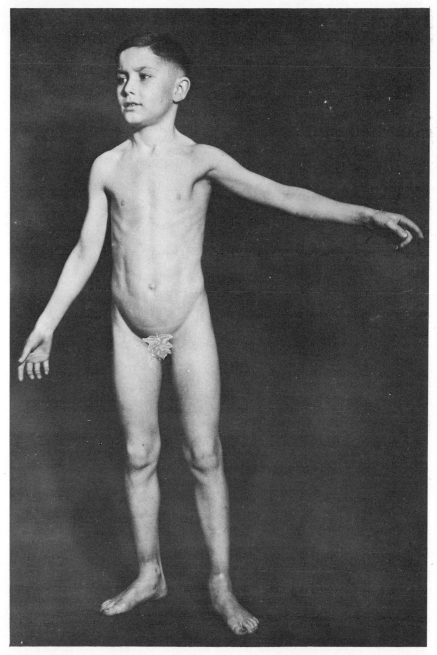

Fig. 122.—Figure of a child, anterior view.

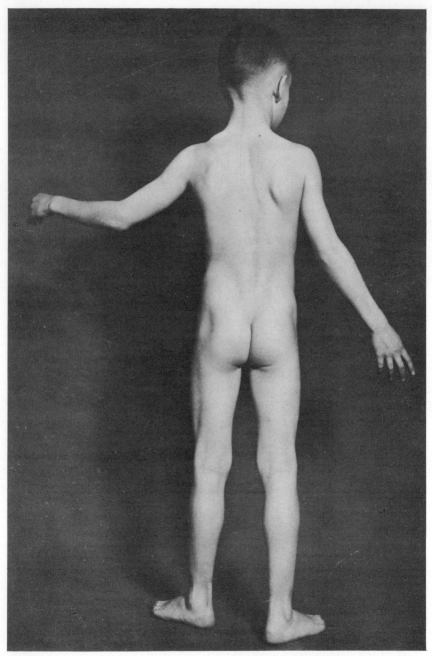

FIG. 123.—Figure of a child, posterior view.

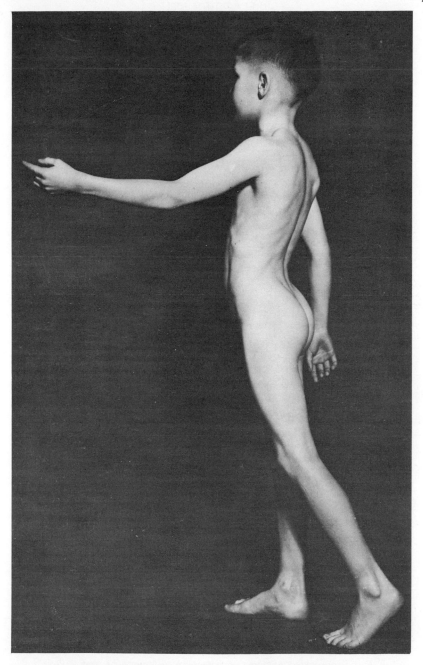

FIG. 124.—Figure of a child, viewed from the left side.

CHAPTER XII

POSES OF THE MALE AND FEMALE FIGURE

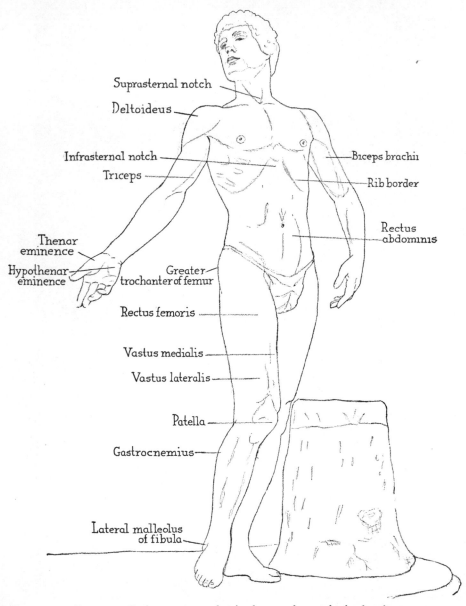

Suprasternal notch

Deltoideus

Infrasternal notch

Triceps

Biceps brachii

Rib border

Rectus abdominis

Thenar eminence

Hypothenar eminence

Greater trochanter of femur

Rectus femoris

Vastus medialis

Vastus lateralis

Patella

Gastrocnemius

Lateral malleolus of fibula

Fig. 125.—Surface anatomy, showing bony and muscular landmarks.

FIG. 126.—Ted Shawn, from his dance, "Death of Adonis."

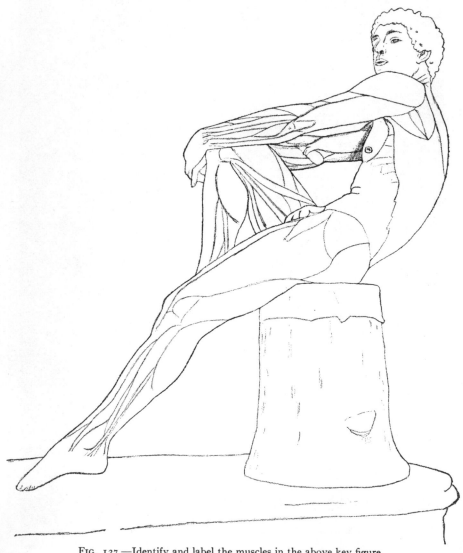

FIG. 127.—Identify and label the muscles in the above key figure.

FIG. 128.—Ted Shawn, from his dance, "Death of Adonis."

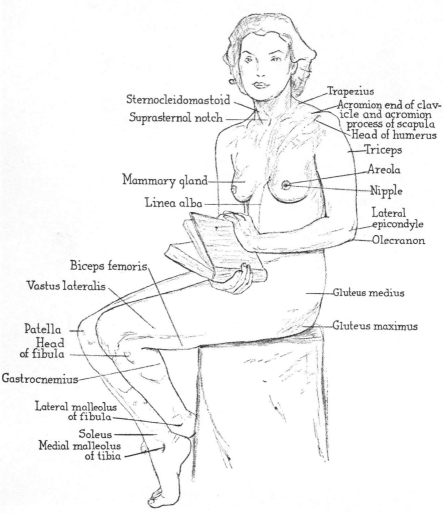

Sternocleidomastoid

Suprasternal notch

Trapezius

Acromion end of clavicle and acromion process of scapula

Head of humerus

Triceps

Mammary gland

Areola

Linea alba

Nipple

Lateral epicondyle

Olecranon

Biceps femoris

Vastus lateralis

Gluteus medius

Patella

Head of fibula

Gluteus maximus

Gastrocnemius

Lateral malleolus of fibula

Soleus

Medial malleolus of tibia

Fig. 129.—Surface anatomy, showing bony and muscular landmarks.

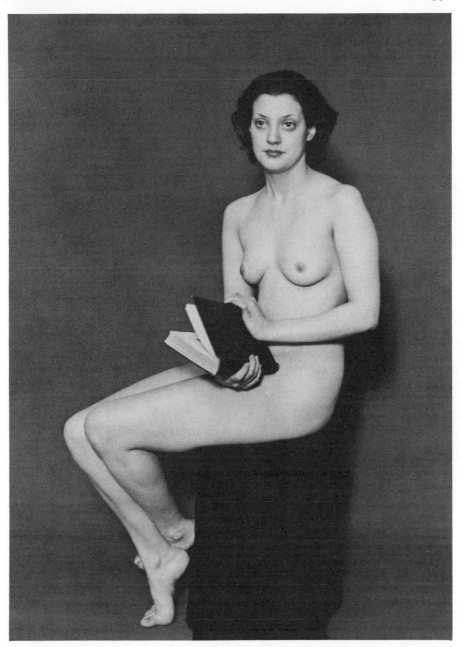

FIG. 130.—Girl seated.

THE MAMMARY GLAND

The **mammary gland** or **breast** is rudimentary in the male. In the female the gland remains undeveloped from the first year (infancy) up to the fourteenth year (puberty), when it increases in size, for a time, due to greater blood supply and accumulation of fat.

The gland measures about one-half inch in diameter at puberty and is increased to over four inches in the adult. The thickness of the adult mammary gland varies with the individual, depending upon conditions and the accumulation of fat, the average being two inches. The nipple is located in the fourth interspace usually and its circular area of pigmented skin, the areola, is pinkish-red, turning dark red during and after child-birth.

In Fig. 131, observe the right gland is located between the second and sixth ribs from the sternum to the anterior border of the axilla (armpit), lying chiefly on the pectoralis major muscle, and somewhat on the serratus anterior and rectus abdominis. The left gland is lower due to the position of the arm and trunk. Observe also the following structures:

> Sternocleidomastoids.
> Laryngeal prominence (Adam's apple) due to thyroid cartilage.
> Pectoralis major insertion (left side).
> Anterior superior spine of ilium.
> Peroneus longus tendon.

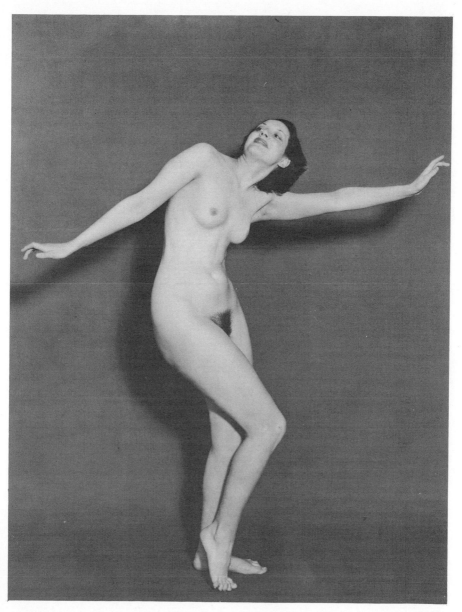

FIG. 131.—Dancing pose.

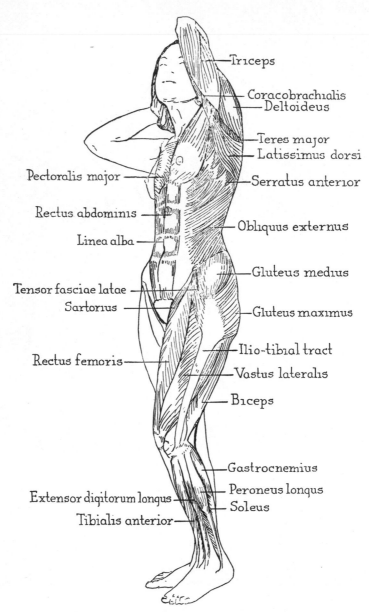

Triceps

Coracobrachialis
Deltoideus

Teres major
Latissimus dorsi

Pectoralis major

Serratus anterior

Rectus abdominis

Linea alba

Obliquus externus

Gluteus medius

Tensor fasciae latae
Sartorius

Gluteus maximus

Rectus femoris

Ilio-tibial tract
Vastus lateralis

Biceps

Gastrocnemius

Extensor digitorum longus

Peroneus longus
Soleus

Tibialis anterior

Fig. 132.—Girl standing showing labeled muscles.

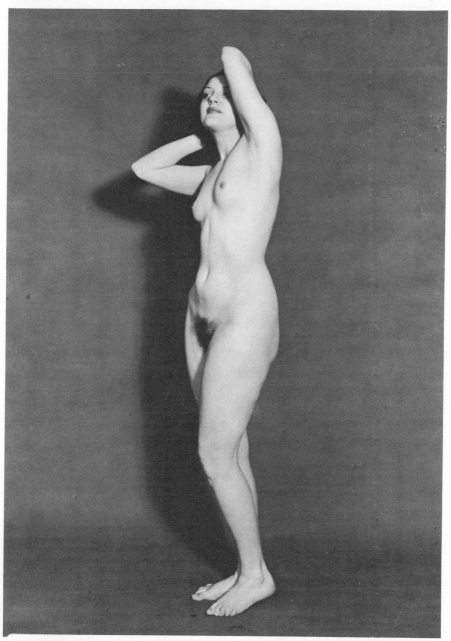

Fig. 133.—Girl standing.

THE TENNIS PLAYER

Notice the general absence of muscular prominences, although this figure is in action. The condition is characteristic of the average female, the muscular prominences being covered by superficial fat. Observe also the altered shape of the breast, as well as the transverse creases on the side at the waist. The hollow evident on the front left elbow is known as the Antecubital Fossa.

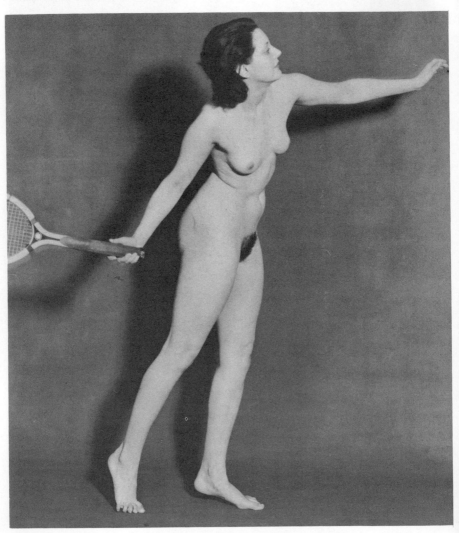

FIG. 134.—Girl tennis player.

THE SPRINTER

In this figure practically every muscle is in action. It is well to note the following structures: the rounded and thick margin of the latissimus dorsi muscle, the contraction of the upper fibres of the deltoideus, the prominence due to the pectoral muscles, and the fan-like serratus anterior muscle. The muscles of the legs and the left arm are beautifully demonstrated. The hollow formed on the back of the knee-joint is known as the Popliteal Fossa. The convexity of the thoracic portion of the vertebral column is well-marked.

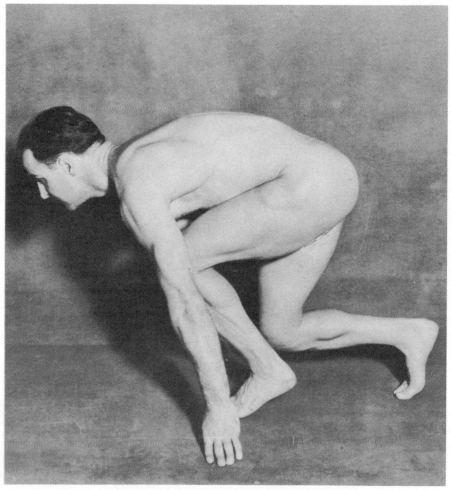

FIG. 135.—The sprinter.

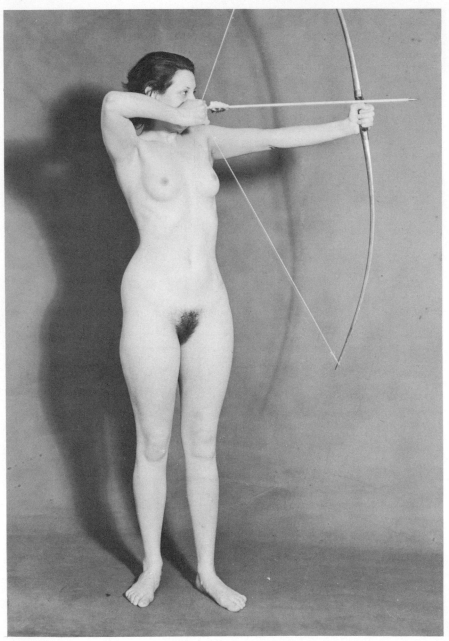

FIG. 136.—Girl archer.

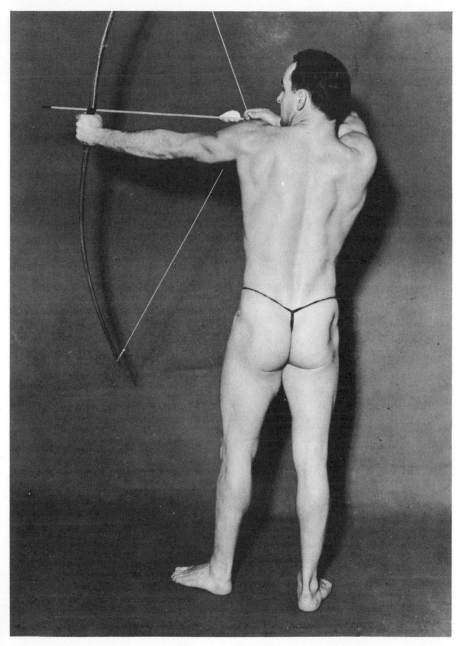

FIG. 137.—Male archer.

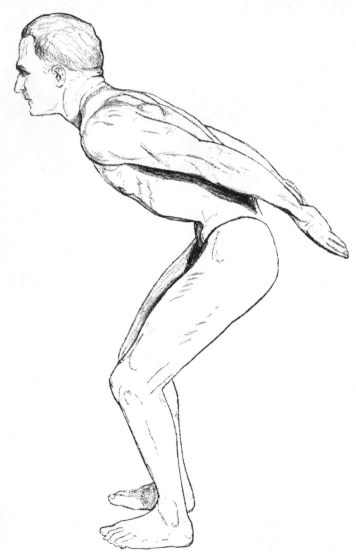

Fig. 138.—Label in the above sketch the anatomical structures evident in Figure 139. Make a memory sketch of the same figure.

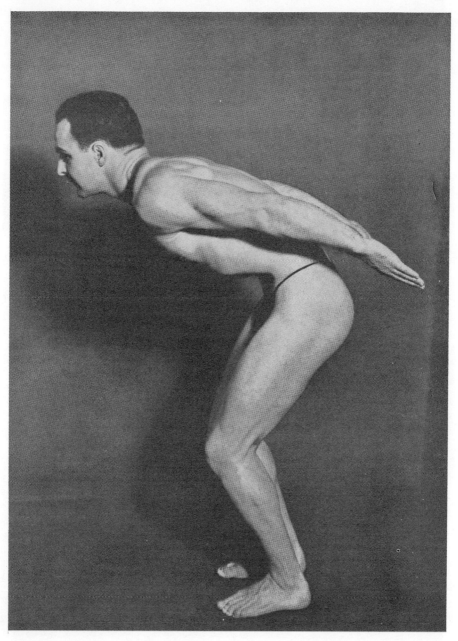

FIG. 139.—The diver.

ACTION PHOTOGRAPHS

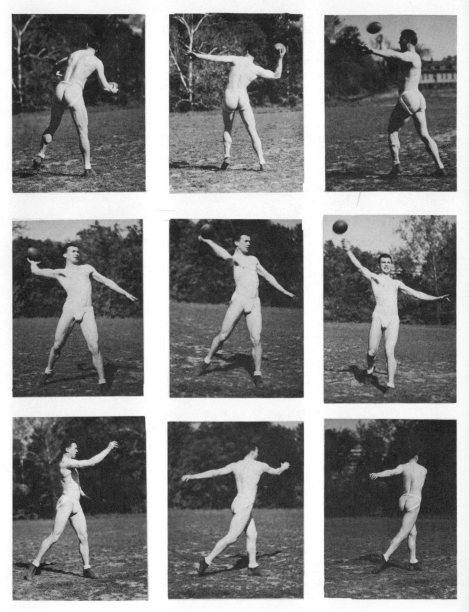

FIG. 140.—Football player showing action and form.

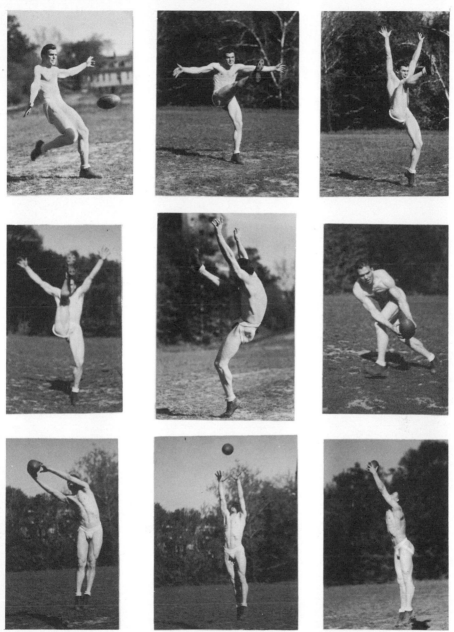

FIG. 141.—Football player showing balance, action, and form.

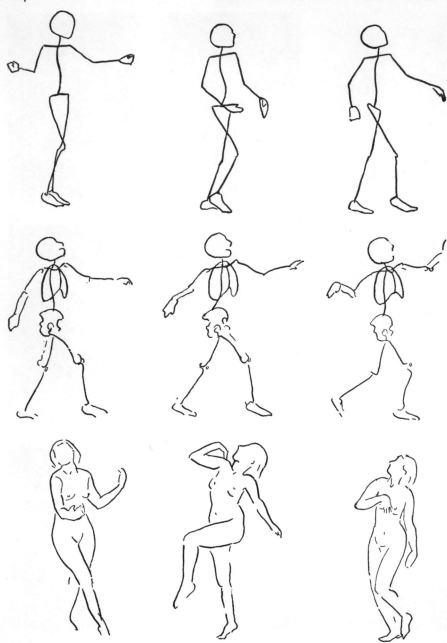

FIG. 142.—Action line sketches.

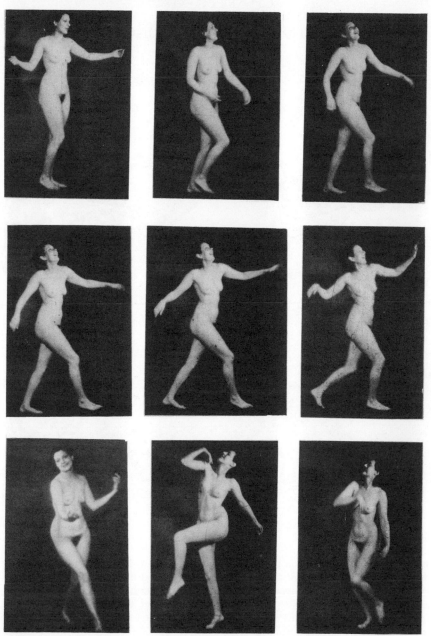

FIG. 143.—Female figure showing rhythm and form.

CHAPTER XIV

STUDENTS' DRAWINGS

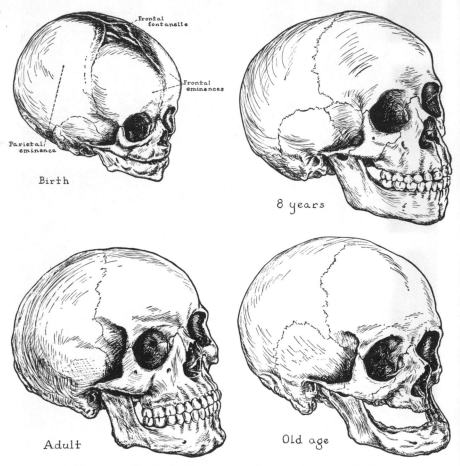

FIG. 144.—Skulls showing comparative age changes at birth, 8 years, adult and old age.

Differences in the Skull Due to Age. At birth the skull is large in proportion to the other parts of the skeleton. Its facial portion is small and is only about one-eighth of the bulk of the skull as compared with one-half in the adult. The parietal and frontal eminences are most prominent. The bones are unossified and membranous intervals termed fontanelles are usually visible at the angles of the bone. The frontal fontanelle is closed during the second year.

The smallness of the face at birth is accounted for mainly by the under-developed condition of the maxilla and mandible, the small size of the nasal cavity and the maxillary sinuses. With the eruption of the milk teeth at two months to two years of age, there is a growth of the face and jaws. These changes are more marked after the second dentition.

Growth of the skull is rapid until the seventh year, the orbital cavities being practically adult size; and at puberty the growth is again active, particularly in the facial and frontal regions, because of the developing air sinuses.

The old-age skull is characterized by diminution in the size of mandible and maxilla with loss of the teeth and absorption of the walls of the alveoli. The chin protrudes and the angle of the mandible tends to revert somewhat to the angle at birth. The vertical mass of the face appears reduced, due to increase in breadth of the skull and diminution of height, with slight increase of the slope of the frontal bone and flattening of the back of the head.

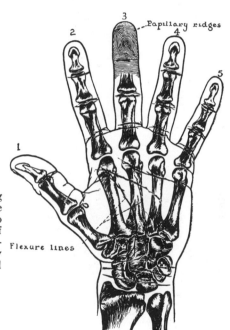

Fig. 145. — Showing the relation of the usual flexure lines to the bony elements of the hand, and arrangement of the papillary ridges on the third terminal phalanx.

The different fingers and toes display various lengths, measuring the relative projection of the tips of the digits from the extremity of the limb. Artists and anatomists describe the middle finger as the longest, and the ring or index fingers as commonly of equal length (i.e., $3 > 4 = 2$). The digital formula for the ideal type of hand is: $3 > 4 = 2 > 5 > 1$. The formula for the digits of the hand of specialization, highest in evolutionary scale, is: $3 > 2 > 4 > 5 > 1$. There are three types of digital formula of the human foot:

A. Commonest type: $1 > 2 > 3 > 4 > 5$. B. "Greek" ideal type: $2 > 1 > 3 > 4 > 5$.
C. Uncommon (or criminal) type: $3 > 2 > 1 > 4 > 5$.

Fig. 146.—Posed Skeleton (student's drawing in competition).

FIG. 147.—Student's sketch.

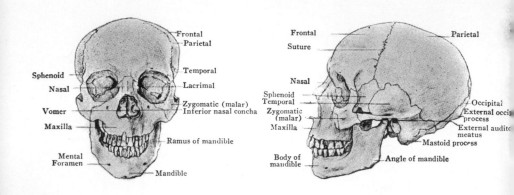

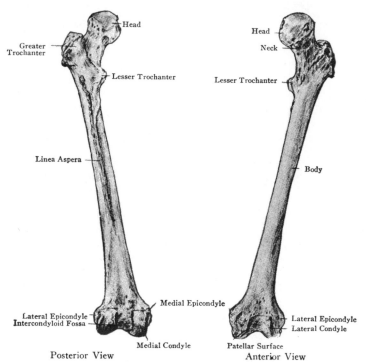

Posterior View Anterior View

Left Thigh Bone, Femur

FIG 148.—Student's sketches of bones.

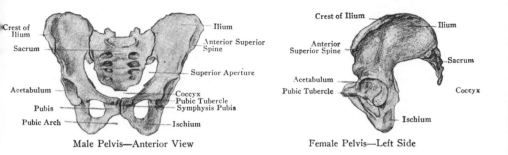

Crest of Ilium
Sacrum
Acetabulum
Pubis
Pubic Arch

Ilium
Anterior Superior Spine
Superior Aperture
Coccyx
Pubic Tubercle
Symphysis Pubis
Ischium

Male Pelvis—Anterior View

Crest of Ilium
Anterior Superior Spine
Acetabulum
Pubic Tubercle

Ilium
Sacrum
Coccyx
Ischium

Female Pelvis—Left Side

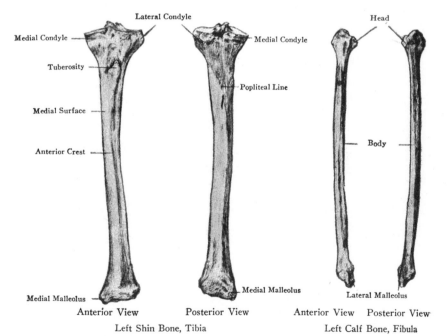

Lateral Condyle
Medial Condyle
Tuberosity
Medial Surface
Anterior Crest
Medial Malleolus

Medial Condyle
Popliteal Line
Medial Malleolus

Head
Body
Lateral Malleolus

Anterior View Posterior View
Left Shin Bone, Tibia

Anterior View Posterior View
Left Calf Bone, Fibula

Fig. 149.—Student's sketches of bones.

CHAPTER XV

GLOSSARY OF ANATOMICAL WORDS AND COMMON MEANING

TERMS INDICATING THE SITE AND DIRECTION OF THE PARTS OF THE BODY

WORD	MEANING
Anterior	in front
Caudal	towards tail
Cranial	towards head
Dorsal	back
External	outside of
Frontal	in front
Inferior	lower
Internal	inner side
Lateral	to side
Medial	middle
Posterior	behind
Profundus	deep
Superficial	above the form (near the surface)
Superior	above
Ventral	in front
Vertex	top

TERMS SPECIALLY USED FOR THE EXTREMITIES

Distal	distant
Proximal	nearest the origin

TERMS SPECIALLY USED IN MOVEMENTS OF PARTS

Abduction	draw away
Adduction	bring toward
Circumduction	draw around
Depression	press down
Elevation	lift up
Eversion	twist about
Extension	stretch out
Flexion	bend
Inversion	turn about
Pronation	turn face down
Protraction	draw forth
Retraction	draw back
Rotation	wheel around, revolve
Supination	turn face up

BONES

Word	Pronunciation	Meaning
Acromion	ak-ro′me-on	tip of shoulder
Astragalus	as-trag′al-us	ankle bone
Calcaneus	kal-ka′ne-us	heel bone
Capitate	kap′it-āt	head
Carpus	kar′pus	wrist
Cervical	ser′vik-al	neck
Clavicle	klav′ik-l	key, collar bone
Coccyx	kok′siks	tail bone
Concha	kong′kah	shell
Coracoid	kor′ak-oid	like crow's beak
Coronoid	kor′o-noid	crow's beak
Corpus	kor′pus	body
Costa	kos′tah	rib, side
Coxa	koks′ah	hip
Cuboid	ku′boid	cube
Cuneiform	ku′ne-if-orm	wedge-shaped
Digit	dij′it	finger
Ethmoid	eth′moid	sieve-like
Femur	fe′mur	thigh bone
Fibula	fib′u-lah	brace bone, root and clasp
Glenoid	gle′noid	socket
Hamate	ha′māt	hooked
Humerus	hu′mer-us	arm bone
Hyoid	hi-oid	u-shaped bone
Ilium	il′e-um	hip, haunch bone
Incus	ing′kus	anvil
Innominate	in-om′in-at	unnamed
Ischium	is′ke-um	hip bone
Lacrimal	lak′rim-al	tear
Lumbar	lum′bar	loin
lunar	lu′nar	moon shaped
Malar	ma′lar	cheek
Malleus	mal′e-us	hammer, to strike
Mandible	man′dib-l	lower jaw
Manubrium	man-u′bre-um	handle
Mastoid	mas′toid	breast
Maxillary	mak′sil-a-re	jawbone
Metacarpal	met-ah-kar′pal	beyond the wrist
Metatarsal	met-ah-tar′sal	beyond the instep
Multangular	mult-ang′u-lar	many angles
Nasal	na′zal	nose
Navicular	na-vik′u-lar	boat-shaped
Occipital	ok-sip′it-al	base of head
Olecranon	o-lek′ran-on	process of ulna at elbow
Palate	pal′at	palate, roof of mouth
Parietal	par-i′et-al	wall
Patella	pat-el′ah	knee pan, pan
Pelvis	pel′vis	basin

WORD	PRONUNCIATION	MEANING
Phalanges	fa-lan'jez	line of soldiers
Pisiform	pi'sif-orm	pea-shaped
Pubis	pu'bis	pubic bone, hair
Radius	ra'de-us	spoke or ray (of wheel)
Sacrum	sa'krum	holy bone, sacred or cursed
Scaphoid	ska'foid	boat-shaped, like a skiff
Scapula	skap'u-lah	spade, shoulder blade
Semilunar	sem-e-lu'nar	half-moon
Sphenoid	sfe'noid	wedge-shaped
Stapes	sta'pēz	stirrup
Sternum	ster'num	flat, breast bone
Talus	ta'lus	one of a set of dice, ankle bone
Tarsus	tahr'sus	instep
Temporal	tem'por-al	time, temple
Thorax	tho'raks	chest, cage
Tibia	tib'e-ah	shin bone, flute
Trapezoid	trap'ez-oid	table, square wrist bone
Triquetrum	tri-kwe'trum	triangular
Ulna	ul'nah	elbow
Vertebra	ver'te-brah	to turn, spindle bone
Vomer	vo'mer	ploughshare
Xiphoid	zi'foid	like a sword
Zygomatic	zi-go-mat'ik	cheek

MUSCLES

WORD	PRONUNCIATION	MEANING
Abductor	ab-duk'tor	leader away
pollicis	pol'licis	of the thumb
longus	long'us	long
pedis	pe'dis	foot
hallucis	hallu'cis	of the great toe
digiti	dig'iti	fingers
quinti	quin'ti	fifth
Achilles tendon	ak-il'ez	a Greek warrior who was vulnerable only in the heel
Adductor	ad-uk'tor	leader to
magnus	mag'nus	great
minimus	min'imus	little
Anconeus	an-ko'ne-us	pertaining to the elbow
Biceps	bi'seps	double headed
brachii	bra'chii	pertaining to the arm
femoris	fem'oris	thigh
Brachialis	bra-ke-a'lis	pertaining to the arm
Brachioradialis	brak″e-o-ra-de-a'lis	arm to radius
Buccinator	buk'sin-a-tor	trumpeter's muscle
Caninus	ka-ni'nus	sharp pointed (dog)

WORD	PRONUNCIATION	MEANING
Coraco	kor'ak-o	beak-like
Deltoid	del'toid	like Greek letter Delta (Δ)
Digastricus	di-gas'trik-us	double bellied
Epicranius	ep-ik-ra'ne-us	
epi		upon
cranius		head
Extensor	ex-ten'sor	extender
communis	commu'nis	common
carpi	car'pi	wrist
ulnaris	ulna'ris	pertaining to ulna
proprius	pro'prius	proper
indicis	in'dicis	first finger
Flexor	fleks'or	bender
profundus	profun'dus	deep
sublimis	subli'mis	superficial
Gastrocnemius	gas-trok-ne'me-us	
gastro		belly
nemius		leg
Gluteus	glu-te'us	buttocks
maximus	max'imus	greatest
medius	me'dius	middle
minimus	min'imus	lesser
Gracilis	gras'il-is	slender
Iliacus	il-i'ak-us	pertaining to the iliac bone
Infraspinatus	in"frah-spi-na'tus	
infra		below
spinatus		spine
Intercostal	in-ter-kos'tal	between the ribs
externus		outside, or external
internus		inside, or internal
Latissimus	lat-is'im-us	broadest
dorsi	dor'si	back
Levator	le-va'tor	lifter
labii	la'bii	lips
menti	men'ti	chin
Longissimus	lon-jis'im-us	longest
Longus	long'us	long
colli	col'li	neck
Lumbricalis	lum-brik-a'lis	worm-shaped
Masseter	mas-e'ter	chewer
Mylohyoid	mi-lo-hi'oid	pertaining to lower jaw teeth and hyoid bone
Obliquus	ob-li'kwus	oblique
abdominis	abdom'inis	abdomen
capitis	cap'itis	head
Obturator	ob'tu-ra-tor	stopper

WORD	PRONUNCIATION	MEANING
Opponens	op-o′nenz	opposing
Orbicularis	or″bik-u-la′ris	circular
ꭇris	o′ris	mouth
oculi	oc′uli	eye
Palmaris	pal-ma′ris	palmar
Pectineus	pek-tin′e-us	pertaining to attachment on pubic bone
Pectoralis	pek-to-ra′lis	pertaining to the breast
major	ma′jor	greater
minor	mi′nor	lesser
Peroneus	per-o-ne′us	fibular (pin)
tertius	ter′tius	third
Plantaris	plan-ta′ris	pertaining to the sole of foot
Platysma	pla-tiz′mah	the muscle-like expansion
Popliteus	pop-lit-e′us	posterior surface of knee (hamstring muscles)
Pronator	pro-na′tor	turner down
quadratus	quadra′ꭇus	square
teres	te′res	round
Psoas	so′as	loin
Piriformis	pir-if-or′mis	pear-shaped
Rectus	rek′tus	straight
femoris	fem′oris	thigh
Rhomboideus	rom-boid′e-us	quadrilateral
Risorius	ri-so′re-us	laughing muscle
Sacrospinalis	sa″kro-spi-na′lis	attached from sacrum along spine
Sartorius	sar-to′re-us	tailor's muscle, used in crossing legs
Scalenus	ska-le′nus	irregular, triangular, uneven
Semimembranosus	sem″e-mem-bran-o′sus	half membranous
Semitendinosus	sem″e-ten-din-o′sus	half tendinous
Semispinalis	sem″e-spi-na′lis	attached to one-half of spine
Serratus	ser-a′tus	toothed
Soleus	so′le-us	sandal, pertaining to the sole
Splenius	sple′ne-us	bandage
Sternocleidomastcid	ster″no-kli-do-mas′toid	
sterno		sternum
cleido		clavicle
mastoid		mastoid process of temporal bone
Subclavius	sub-kla′ve-us	
sub		below
clavius		clavicle
Subscapular	sub-skap′u-lar	below scapular spine
Supinator	su-pin-a′tor	lying on the back
Temporalis	tem-por-a′lis	time, the first place gray hair appears (temple)
Thenar	the′nar	palm
hypo		less than

Word	Pronunciation	Meaning
Tibialis	tib-e-a′lis	attached to tibia
Trapezius	trap-e′ze-us	table-like
Triceps	tri′seps	three-headed
Vastus	vas′tus	large
Zygomaticus	zi-go-mat′ik-us	pertaining to cheek

A CATALOGUE OF SELECTED DOVER BOOKS
IN ALL FIELDS OF INTEREST

A CATALOGUE OF SELECTED DOVER BOOKS
IN ALL FIELDS OF INTEREST

AMERICA'S OLD MASTERS, James T. Flexner. Four men emerged unexpectedly from provincial 18th century America to leadership in European art: Benjamin West, J. S. Copley, C. R. Peale, Gilbert Stuart. Brilliant coverage of lives and contributions. Revised, 1967 edition. 69 plates. 365pp. of text.
21806-6 Paperbound $3.00

FIRST FLOWERS OF OUR WILDERNESS: AMERICAN PAINTING, THE COLONIAL PERIOD, James T. Flexner. Painters, and regional painting traditions from earliest Colonial times up to the emergence of Copley, West and Peale Sr., Foster, Gustavus Hesselius, Feke, John Smibert and many anonymous painters in the primitive manner. Engaging presentation, with 162 illustrations. xxii + 368pp.
22180-6 Paperbound $3.50

THE LIGHT OF DISTANT SKIES: AMERICAN PAINTING, 1760-1835, James T. Flexner. The great generation of early American painters goes to Europe to learn and to teach: West, Copley, Gilbert Stuart and others. Allston, Trumbull, Morse; also contemporary American painters—primitives, derivatives, academics—who remained in America. 102 illustrations. xiii + 306pp.
22179-2 Paperbound $3.00

A HISTORY OF THE RISE AND PROGRESS OF THE ARTS OF DESIGN IN THE UNITED STATES, William Dunlap. Much the richest mine of information on early American painters, sculptors, architects, engravers, miniaturists, etc. The only source of information for scores of artists, the major primary source for many others. Unabridged reprint of rare original 1834 edition, with new introduction by James T. Flexner, and 394 new illustrations. Edited by Rita Weiss. 6⅜ x 9⅝.
21695-0, 21696-9, 21697-7 Three volumes, Paperbound $13.50

EPOCHS OF CHINESE AND JAPANESE ART, Ernest F. Fenollosa. From primitive Chinese art to the 20th century, thorough history, explanation of every important art period and form, including Japanese woodcuts; main stress on China and Japan, but Tibet, Korea also included. Still unexcelled for its detailed, rich coverage of cultural background, aesthetic elements, diffusion studies, particularly of the historical period. 2nd, 1913 edition. 242 illustrations. lii + 439pp. of text.
20364-6, 20365-4 Two volumes, Paperbound $6.00

THE GENTLE ART OF MAKING ENEMIES, James A. M. Whistler. Greatest wit of his day deflates Oscar Wilde, Ruskin, Swinburne; strikes back at inane critics, exhibitions, art journalism; aesthetics of impressionist revolution in most striking form. Highly readable classic by great painter. Reproduction of edition designed by Whistler. Introduction by Alfred Werner. xxxvi + 334pp.
21875-9 Paperbound $2.50

THE ARCHITECTURE OF COUNTRY HOUSES, Andrew J. Downing. Together with Vaux's *Villas and Cottages* this is the basic book for Hudson River Gothic architecture of the middle Victorian period. Full, sound discussions of general aspects of housing, architecture, style, decoration, furnishing, together with scores of detailed house plans, illustrations of specific buildings, accompanied by full text. Perhaps the most influential single American architectural book. 1850 edition. Introduction by J. Stewart Johnson. 321 figures, 34 architectural designs. xvi + 560pp.
22003-6 Paperbound $4.00

LOST EXAMPLES OF COLONIAL ARCHITECTURE, John Mead Howells. Full-page photographs of buildings that have disappeared or been so altered as to be denatured, including many designed by major early American architects. 245 plates. xvii + 248pp. 7⅞ x 10¾.
21143-6 Paperbound $3.50

DOMESTIC ARCHITECTURE OF THE AMERICAN COLONIES AND OF THE EARLY REPUBLIC, Fiske Kimball. Foremost architect and restorer of Williamsburg and Monticello covers nearly 200 homes between 1620-1825. Architectural details, construction, style features, special fixtures, floor plans, etc. Generally considered finest work in its area. 219 illustrations of houses, doorways, windows, capital mantels. xx + 314pp. 7⅞ x 10¾.
21743-4 Paperbound $4.00

EARLY AMERICAN ROOMS: 1650-1858, edited by Russell Hawes Kettell. Tour of 12 rooms, each representative of a different era in American history and each furnished, decorated, designed and occupied in the style of the era. 72 plans and elevations, 8-page color section, etc., show fabrics, wall papers, arrangements, etc. Full descriptive text. xvii + 200pp. of text. 8⅜ x 11¼.
21633-0 Paperbound $5.00

THE FITZWILLIAM VIRGINAL BOOK, edited by J. Fuller Maitland and W. B. Squire. Full modern printing of famous early 17th-century ms. volume of 300 works by Morley, Byrd, Bull, Gibbons, etc. For piano or other modern keyboard instrument; easy to read format. xxxvi + 938pp. 8⅜ x 11.
21068-5, 21069-3 Two volumes, Paperbound $10.00

KEYBOARD MUSIC, Johann Sebastian Bach. Bach Gesellschaft edition. A rich selection of Bach's masterpieces for the harpsichord: the six English Suites, six French Suites, the six Partitas (Clavierübung part I), the Goldberg Variations (Clavierübung part IV), the fifteen Two-Part Inventions and the fifteen Three-Part Sinfonias. Clearly reproduced on large sheets with ample margins; eminently playable. vi + 312pp. 8⅛ x 11.
22360-4 Paperbound $5.00

THE MUSIC OF BACH: AN INTRODUCTION, Charles Sanford Terry. A fine, nontechnical introduction to Bach's music, both instrumental and vocal. Covers organ music, chamber music, passion music, other types. Analyzes themes, developments, innovations. x + 114pp.
21075-8 Paperbound $1.25

BEETHOVEN AND HIS NINE SYMPHONIES, Sir George Grove. Noted British musicologist provides best history, analysis, commentary on symphonies. Very thorough, rigorously accurate; necessary to both advanced student and amateur music lover. 436 musical passages. vii + 407 pp.
20334-4 Paperbound $2.75

JOHANN SEBASTIAN BACH, Philipp Spitta. One of the great classics of musicology, this definitive analysis of Bach's music (and life) has never been surpassed. Lucid, nontechnical analyses of hundreds of pieces (30 pages devoted to St. Matthew Passion, 26 to B Minor Mass). Also includes major analysis of 18th-century music. 450 musical examples. 40-page musical supplement. Total of xx + 1799pp.
(EUK) 22278-0, 22279-9 Two volumes, Clothbound $15.00

MOZART AND HIS PIANO CONCERTOS, Cuthbert Girdlestone. The only full-length study of an important area of Mozart's creativity. Provides detailed analyses of all 23 concertos, traces inspirational sources. 417 musical examples. Second edition. 509pp. (USO) 21271-8 Paperbound $3.50

THE PERFECT WAGNERITE: A COMMENTARY ON THE NIBLUNG'S RING, George Bernard Shaw. Brilliant and still relevant criticism in remarkable essays on Wagner's Ring cycle, Shaw's ideas on political and social ideology behind the plots, role of Leitmotifs, vocal requisites, etc. Prefaces. xxi + 136pp.
21707-8 Paperbound $1.50

DON GIOVANNI, W. A. Mozart. Complete libretto, modern English translation; biographies of composer and librettist; accounts of early performances and critical reaction. Lavishly illustrated. All the material you need to understand and appreciate this great work. Dover Opera Guide and Libretto Series; translated and introduced by Ellen Bleiler. 92 illustrations. 209pp.
21134-7 Paperbound $1.50

HIGH FIDELITY SYSTEMS: A LAYMAN'S GUIDE, Roy F. Allison. All the basic information you need for setting up your own audio system: high fidelity and stereo record players, tape records, F.M. Connections, adjusting tone arm, cartridge, checking needle alignment, positioning speakers, phasing speakers, adjusting hums, trouble-shooting, maintenance, and similar topics. Enlarged 1965 edition. More than 50 charts, diagrams, photos. iv + 91pp. 21514-8 Paperbound $1.25

REPRODUCTION OF SOUND, Edgar Villchur. Thorough coverage for laymen of high fidelity systems, reproducing systems in general, needles, amplifiers, preamps, loudspeakers, feedback, explaining physical background. "A rare talent for making technicalities vividly comprehensible," R. Darrell, *High Fidelity*. 69 figures. iv + 92pp. 21515-6 Paperbound $1.00

HEAR ME TALKIN' TO YA: THE STORY OF JAZZ AS TOLD BY THE MEN WHO MADE IT, Nat Shapiro and Nat Hentoff. Louis Armstrong, Fats Waller, Jo Jones, Clarence Williams, Billy Holiday, Duke Ellington, Jelly Roll Morton and dozens of other jazz greats tell how it was in Chicago's South Side, New Orleans, depression Harlem and the modern West Coast as jazz was born and grew. xvi + 429pp.
21726-4 Paperbound $2.50

FABLES OF AESOP, translated by Sir Roger L'Estrange. A reproduction of the very rare 1931 Paris edition; a selection of the most interesting fables, together with 50 imaginative drawings by Alexander Calder. v + 128pp. 6½x9¼.
21780-9 Paperbound $1.25

AGAINST THE GRAIN (A REBOURS), Joris K. Huysmans. Filled with weird images, evidences of a bizarre imagination, exotic experiments with hallucinatory drugs, rich tastes and smells and the diversions of its sybarite hero Duc Jean des Esseintes, this classic novel pushed 19th-century literary decadence to its limits. Full unabridged edition. Do not confuse this with abridged editions generally sold. Introduction by Havelock Ellis. xlix + 206pp. 22190-3 Paperbound $2.00

VARIORUM SHAKESPEARE: HAMLET. Edited by Horace H. Furness; a landmark of American scholarship. Exhaustive footnotes and appendices treat all doubtful words and phrases, as well as suggested critical emendations throughout the play's history. First volume contains editor's own text, collated with all Quartos and Folios. Second volume contains full first Quarto, translations of Shakespeare's sources (Belleforest, and Saxo Grammaticus), Der Bestrafte Brudermord, and many essays on critical and historical points of interest by major authorities of past and present. Includes details of staging and costuming over the years. By far the best edition available for serious students of Shakespeare. Total of xx + 905pp. 21004-9, 21005-7, 2 volumes, Paperbound $7.00

A LIFE OF WILLIAM SHAKESPEARE, Sir Sidney Lee. This is the standard life of Shakespeare, summarizing everything known about Shakespeare and his plays. Incredibly rich in material, broad in coverage, clear and judicious, it has served thousands as the best introduction to Shakespeare. 1931 edition. 9 plates. xxix + 792pp. (USO) 21967-4 Paperbound $3.75

MASTERS OF THE DRAMA, John Gassner. Most comprehensive history of the drama in print, covering every tradition from Greeks to modern Europe and America, including India, Far East, etc. Covers more than 800 dramatists, 2000 plays, with biographical material, plot summaries, theatre history, criticism, etc. "Best of its kind in English," New Republic. 77 illustrations. xxii + 890pp. 20100-7 Clothbound $8.50

THE EVOLUTION OF THE ENGLISH LANGUAGE, George McKnight. The growth of English, from the 14th century to the present. Unusual, non-technical account presents basic information in very interesting form: sound shifts, change in grammar and syntax, vocabulary growth, similar topics. Abundantly illustrated with quotations. Formerly Modern English in the Making. xii + 590pp. 21932-1 Paperbound $3.50

AN ETYMOLOGICAL DICTIONARY OF MODERN ENGLISH, Ernest Weekley. Fullest, richest work of its sort, by foremost British lexicographer. Detailed word histories, including many colloquial and archaic words; extensive quotations. Do not confuse this with the Concise Etymological Dictionary, which is much abridged. Total of xxvii + 830pp. 6½ x 9¼. 21873-2, 21874-0 Two volumes, Paperbound $6.00

FLATLAND: A ROMANCE OF MANY DIMENSIONS, E. A. Abbott. Classic of science-fiction explores ramifications of life in a two-dimensional world, and what happens when a three-dimensional being intrudes. Amusing reading, but also useful as introduction to thought about hyperspace. Introduction by Banesh Hoffmann. 16 illustrations. xx + 103pp. 20001-9 Paperbound $1.00

POEMS OF ANNE BRADSTREET, edited with an introduction by Robert Hutchinson. A new selection of poems by America's first poet and perhaps the first significant woman poet in the English language. 48 poems display her development in works of considerable variety—love poems, domestic poems, religious meditations, formal elegies, "quaternions," etc. Notes, bibliography. viii + 222pp.
22160-1 Paperbound $2.00

THREE GOTHIC NOVELS: THE CASTLE OF OTRANTO BY HORACE WALPOLE; VATHEK BY WILLIAM BECKFORD; THE VAMPYRE BY JOHN POLIDORI, WITH FRAGMENT OF A NOVEL BY LORD BYRON, edited by E. F. Bleiler. The first Gothic novel, by Walpole; the finest Oriental tale in English, by Beckford; powerful Romantic supernatural story in versions by Polidori and Byron. All extremely important in history of literature; all still exciting, packed with supernatural thrills, ghosts, haunted castles, magic, etc. xl + 291pp.
21232-7 Paperbound $2.50

THE BEST TALES OF HOFFMANN, E. T. A. Hoffmann. 10 of Hoffmann's most important stories, in modern re-editings of standard translations: Nutcracker and the King of Mice, Signor Formica, Automata, The Sandman, Rath Krespel, The Golden Flowerpot, Master Martin the Cooper, The Mines of Falun, The King's Betrothed, A New Year's Eve Adventure. 7 illustrations by Hoffmann. Edited by E. F. Bleiler. xxxix + 419pp.
21793-0 Paperbound $3.00

GHOST AND HORROR STORIES OF AMBROSE BIERCE, Ambrose Bierce. 23 strikingly modern stories of the horrors latent in the human mind: The Eyes of the Panther, The Damned Thing, An Occurrence at Owl Creek Bridge, An Inhabitant of Carcosa, etc., plus the dream-essay, Visions of the Night. Edited by E. F. Bleiler. xxii + 199pp.
20767-6 Paperbound $1.50

BEST GHOST STORIES OF J. S. LEFANU, J. Sheridan LeFanu. Finest stories by Victorian master often considered greatest supernatural writer of all. Carmilla, Green Tea, The Haunted Baronet, The Familiar, and 12 others. Most never before available in the U. S. A. Edited by E. F. Bleiler. 8 illustrations from Victorian publications. xvii + 467pp.
20415-4 Paperbound $3.00

MATHEMATICAL FOUNDATIONS OF INFORMATION THEORY, A. I. Khinchin. Comprehensive introduction to work of Shannon, McMillan, Feinstein and Khinchin, placing these investigations on a rigorous mathematical basis. Covers entropy concept in probability theory, uniqueness theorem, Shannon's inequality, ergodic sources, the E property, martingale concept, noise, Feinstein's fundamental lemma, Shanon's first and second theorems. Translated by R. A. Silverman and M. D. Friedman. iii + 120pp.
60434-9 Paperbound $1.75

SEVEN SCIENCE FICTION NOVELS, H. G. Wells. The standard collection of the great novels. Complete, unabridged. *First Men in the Moon, Island of Dr. Moreau, War of the Worlds, Food of the Gods, Invisible Man, Time Machine, In the Days of the Comet.* Not only science fiction fans, but every educated person owes it to himself to read these novels. 1015pp
20264-X Clothbound $5.00

LAST AND FIRST MEN AND STAR MAKER, TWO SCIENCE FICTION NOVELS, Olaf Stapledon. Greatest future histories in science fiction. In the first, human intelligence is the "hero," through strange paths of evolution, interplanetary invasions, incredible technologies, near extinctions and reemergences. Star Maker describes the quest of a band of star rovers for intelligence itself, through time and space: weird inhuman civilizations, crustacean minds, symbiotic worlds, etc. Complete, unabridged. v + 438pp. 21962-3 Paperbound $2.50

THREE PROPHETIC NOVELS, H. G. WELLS. Stages of a consistently planned future for mankind. *When the Sleeper Wakes,* and *A Story of the Days to Come,* anticipate *Brave New World* and *1984,* in the 21st Century; *The Time Machine,* only complete version in print, shows farther future and the end of mankind. All show Wells's greatest gifts as storyteller and novelist. Edited by E. F. Bleiler. x + 335pp. (USO) 20605-X Paperbound $2.50

THE DEVIL'S DICTIONARY, Ambrose Bierce. America's own Oscar Wilde— Ambrose Bierce—offers his barbed iconoclastic wisdom in over 1,000 definitions hailed by H. L. Mencken as "some of the most gorgeous witticisms in the English language." 145pp. 20487-1 Paperbound $1.25

MAX AND MORITZ, Wilhelm Busch. Great children's classic, father of comic strip, of two bad boys, Max and Moritz. Also Ker and Plunk (Plisch und Plumm), Cat and Mouse, Deceitful Henry, Ice-Peter, The Boy and the Pipe, and five other pieces. Original German, with English translation. Edited by H. Arthur Klein; translations by various hands and H. Arthur Klein. vi + 216pp. 20181-3 Paperbound $2.00

PIGS IS PIGS AND OTHER FAVORITES, Ellis Parker Butler. The title story is one of the best humor short stories, as Mike Flannery obfuscates biology and English. Also included, That Pup of Murchison's, The Great American Pie Company, and Perkins of Portland. 14 illustrations. v + 109pp. 21532-6 Paperbound $1.25

THE PETERKIN PAPERS, Lucretia P. Hale. It takes genius to be as stupidly mad as the Peterkins, as they decide to become wise, celebrate the "Fourth," keep a cow, and otherwise strain the resources of the Lady from Philadelphia. Basic book of American humor. 153 illustrations. 219pp. 20794-3 Paperbound $1.50

PERRAULT'S FAIRY TALES, translated by A. E. Johnson and S. R. Littlewood, with 34 full-page illustrations by Gustave Doré. All the original Perrault stories— Cinderella, Sleeping Beauty, Bluebeard, Little Red Riding Hood, Puss in Boots, Tom Thumb, etc.—with their witty verse morals and the magnificent illustrations of Doré. One of the five or six great books of European fairy tales. viii + 117pp. 8⅛ x 11. 22311-6 Paperbound $2.00

OLD HUNGARIAN FAIRY TALES, Baroness Orczy. Favorites translated and adapted by author of the *Scarlet Pimpernel.* Eight fairy tales include "The Suitors of Princess Fire-Fly," "The Twin Hunchbacks," "Mr. Cuttlefish's Love Story," and "The Enchanted Cat." This little volume of magic and adventure will captivate children as it has for generations. 90 drawings by Montagu Barstow. 96pp. (USO) 22293-4 Paperbound $1.95

A History of Costume, Carl Köhler. Definitive history, based on surviving pieces of clothing primarily, and paintings, statues, etc. secondarily. Highly readable text, supplemented by 594 illustrations of costumes of the ancient Mediterranean peoples, Greece and Rome, the Teutonic prehistoric period; costumes of the Middle Ages, Renaissance, Baroque, 18th and 19th centuries. Clear, measured patterns are provided for many clothing articles. Approach is practical throughout. Enlarged by Emma von Sichart. 464pp. 21030-8 Paperbound $3.50

Oriental Rugs, Antique and Modern, Walter A. Hawley. A complete and authoritative treatise on the Oriental rug—where they are made, by whom and how, designs and symbols, characteristics in detail of the six major groups, how to distinguish them and how to buy them. Detailed technical data is provided on periods, weaves, warps, wefts, textures, sides, ends and knots, although no technical background is required for an understanding. 11 color plates, 80 halftones, 4 maps. vi + 320pp. 6⅛ x 9⅛. 22366-3 Paperbound $5.00

Ten Books on Architecture, Vitruvius. By any standards the most important book on architecture ever written. Early Roman discussion of aesthetics of building, construction methods, orders, sites, and every other aspect of architecture has inspired, instructed architecture for about 2,000 years. Stands behind Palladio, Michelangelo, Bramante, Wren, countless others. Definitive Morris H. Morgan translation. 68 illustrations. xii + 331pp. 20645-9 Paperbound $3.50

The Four Books of Architecture, Andrea Palladio. Translated into every major Western European language in the two centuries following its publication in 1570, this has been one of the most influential books in the history of architecture. Complete reprint of the 1738 Isaac Ware edition. New introduction by Adolf Placzek, Columbia Univ. 216 plates. xxii + 110pp. of text. 9½ x 12¾. 21308-0 Clothbound $10.00

Sticks and Stones: A Study of American Architecture and Civilization, Lewis Mumford.One of the great classics of American cultural history. American architecture from the medieval-inspired earliest forms to the early 20th century; evolution of structure and style, and reciprocal influences on environment. 21 photographic illustrations. 238pp. 20202-X Paperbound $2.00

The American Builder's Companion, Asher Benjamin. The most widely used early 19th century architectural style and source book, for colonial up into Greek Revival periods. Extensive development of geometry of carpentering, construction of sashes, frames, doors, stairs; plans and elevations of domestic and other buildings. Hundreds of thousands of houses were built according to this book, now invaluable to historians, architects, restorers, etc. 1827 edition. 59 plates. 114pp. 7⅞ x 10¾. 22236-5 Paperbound $3.50

Dutch Houses in the Hudson Valley Before 1776, Helen Wilkinson Reynolds. The standard survey of the Dutch colonial house and outbuildings, with constructional features, decoration, and local history associated with individual homesteads. Introduction by Franklin D. Roosevelt. Map. 150 illustrations. 469pp. 6⅝ x 9¼. 21469-9 Paperbound $4.00

CATALOGUE OF DOVER BOOKS

ALPHABETS AND ORNAMENTS, Ernst Lehner. Well-known pictorial source for decorative alphabets, script examples, cartouches, frames, decorative title pages, calligraphic initials, borders, similar material. 14th to 19th century, mostly European. Useful in almost any graphic arts designing, varied styles. 750 illustrations. 256pp. 7 x 10. 21905-4 Paperbound $4.00

PAINTING: A CREATIVE APPROACH, Norman Colquhoun. For the beginner simple guide provides an instructive approach to painting: major stumbling blocks for beginner; overcoming them, technical points; paints and pigments; oil painting; watercolor and other media and color. New section on "plastic" paints. Glossary. Formerly *Paint Your Own Pictures.* 221pp. 22000-1 Paperbound $1.75

THE ENJOYMENT AND USE OF COLOR, Walter Sargent. Explanation of the relations between colors themselves and between colors in nature and art, including hundreds of little-known facts about color values, intensities, effects of high and low illumination, complementary colors. Many practical hints for painters, references to great masters. 7 color plates, 29 illustrations. x + 274pp.
20944-X Paperbound $2.75

THE NOTEBOOKS OF LEONARDO DA VINCI, compiled and edited by Jean Paul Richter. 1566 extracts from original manuscripts reveal the full range of Leonardo's versatile genius: all his writings on painting, sculpture, architecture, anatomy, astronomy, geography, topography, physiology, mining, music, etc., in both Italian and English, with 186 plates of manuscript pages and more than 500 additional drawings. Includes studies for the Last Supper, the lost Sforza monument, and other works. Total of xlvii + 866pp. 7⅞ x 10¾.
22572-0, 22573-9 Two volumes, Paperbound $10.00

MONTGOMERY WARD CATALOGUE OF 1895. Tea gowns, yards of flannel and pillow-case lace, stereoscopes, books of gospel hymns, the New Improved Singer Sewing Machine, side saddles, milk skimmers, straight-edged razors, high-button shoes, spittoons, and on and on . . . listing some 25,000 items, practically all illustrated. Essential to the shoppers of the 1890's, it is our truest record of the spirit of the period. Unaltered reprint of Issue No. 57, Spring and Summer 1895. Introduction by Boris Emmet. Innumerable illustrations. xiii + 624pp. 8½ x 11⅝.
22377-9 Paperbound $6.95

THE CRYSTAL PALACE EXHIBITION ILLUSTRATED CATALOGUE (LONDON, 1851). One of the wonders of the modern world—the Crystal Palace Exhibition in which all the nations of the civilized world exhibited their achievements in the arts and sciences—presented in an equally important illustrated catalogue. More than 1700 items pictured with accompanying text—ceramics, textiles, cast-iron work, carpets, pianos, sleds, razors, wall-papers, billiard tables, beehives, silverware and hundreds of other artifacts—represent the focal point of Victorian culture in the Western World. Probably the largest collection of Victorian decorative art ever assembled— indispensable for antiquarians and designers. Unabridged republication of the Art-Journal Catalogue of the Great Exhibition of 1851, with all terminal essays. New introduction by John Gloag, F.S.A. xxxiv + 426pp. 9 x 12.
22503-8 Paperbound $4.50

THE PRINCIPLES OF PSYCHOLOGY, William James. The famous long course, complete and unabridged. Stream of thought, time perception, memory, experimental methods—-these are only some of the concerns of a work that was years ahead of its time and still valid, interesting, useful. 94 figures. Total of xviii + 1391pp.
20381-6, 20382-4 Two volumes, Paperbound $8.00

THE STRANGE STORY OF THE QUANTUM, Banesh Hoffmann. Non-mathematical but thorough explanation of work of Planck, Einstein, Bohr, Pauli, de Broglie, Schrödinger, Heisenberg, Dirac, Feynman, etc. No technical background needed. "Of books attempting such an account, this is the best," Henry Margenau, Yale. 40-page "Postscript 1959." xii + 285pp. 20518-5 Paperbound $2.00

THE RISE OF THE NEW PHYSICS, A. d'Abro. Most thorough explanation in print of central core of mathematical physics, both classical and modern; from Newton to Dirac and Heisenberg. Both history and exposition; philosophy of science, causality, explanations of higher mathematics, analytical mechanics, electromagnetism, thermodynamics, phase rule, special and general relativity, matrices. No higher mathematics needed to follow exposition, though treatment is elementary to intermediate in level. Recommended to serious student who wishes verbal understanding. 97 illustrations. xvii + 982pp. 20003-5, 20004-3 Two volumes, Paperbound $6.00

GREAT IDEAS OF OPERATIONS RESEARCH, Jagjit Singh. Easily followed non-technical explanation of mathematical tools, aims, results: statistics, linear programming, game theory, queueing theory, Monte Carlo simulation, etc. Uses only elementary mathematics. Many case studies, several analyzed in detail. Clarity, breadth make this excellent for specialist in another field who wishes background. 41 figures. x + 228pp. 21886-4 Paperbound $2.50

GREAT IDEAS OF MODERN MATHEMATICS: THEIR NATURE AND USE, Jagjit Singh. Internationally famous expositor, winner of Unesco's Kalinga Award for science popularization explains verbally such topics as differential equations, matrices, groups, sets, transformations, mathematical logic and other important modern mathematics, as well as use in physics, astrophysics, and similar fields. Superb exposition for layman, scientist in other areas. viii + 312pp. 20587-8 Paperbound $2.50

GREAT IDEAS IN INFORMATION THEORY, LANGUAGE AND CYBERNETICS, Jagjit Singh. The analog and digital computers, how they work, how they are like and unlike the human brain, the men who developed them, their future applications, computer terminology. An essential book for today, even for readers with little math. Some mathematical demonstrations included for more advanced readers. 118 figures. Tables. ix + 338pp. 21694-2 Paperbound $2.50

CHANCE, LUCK AND STATISTICS, Horace C. Levinson. Non-mathematical presentation of fundamentals of probability theory and science of statistics and their applications. Games of chance, betting odds, misuse of statistics, normal and skew distributions, birth rates, stock speculation, insurance. Enlarged edition. Formerly "The Science of Chance." xiii + 357pp. 21007-3 Paperbound $2.50

How to Know the Wild Flowers, Mrs. William Starr Dana. This is the classical book of American wildflowers (of the Eastern and Central United States), used by hundreds of thousands. Covers over 500 species, arranged in extremely easy to use color and season groups. Full descriptions, much plant lore. This Dover edition is the fullest ever compiled, with tables of nomenclature changes. 174 full-page plates by M. Satterlee. xii + 418pp. 20332-8 Paperbound $2.75

Our Plant Friends and Foes, William Atherton DuPuy. History, economic importance, essential botanical information and peculiarities of 25 common forms of plant life are provided in this book in an entertaining and charming style. Covers food plants (potatoes, apples, beans, wheat, almonds, bananas, etc.), flowers (lily, tulip, etc.), trees (pine, oak, elm, etc.), weeds, poisonous mushrooms and vines, gourds, citrus fruits, cotton, the cactus family, and much more. 108 illustrations. xiv + 290pp. 22272-1 Paperbound $2.50

How to Know the Ferns, Frances T. Parsons. Classic survey of Eastern and Central ferns, arranged according to clear, simple identification key. Excellent introduction to greatly neglected nature area. 57 illustrations and 42 plates. xvi + 215pp. 20740-4 Paperbound $2.00

Manual of the Trees of North America, Charles S. Sargent. America's foremost dendrologist provides the definitive coverage of North American trees and tree-like shrubs. 717 species fully described and illustrated: exact distribution, down to township; full botanical description; economic importance; description of subspecies and races; habitat, growth data; similar material. Necessary to every serious student of tree-life. Nomenclature revised to present. Over 100 locating keys. 783 illustrations. lii + 934pp. 20277-1, 20278-X Two volumes, Paperbound $6.00

Our Northern Shrubs, Harriet L. Keeler. Fine non-technical reference work identifying more than 225 important shrubs of Eastern and Central United States and Canada. Full text covering botanical description, habitat, plant lore, is paralleled with 205 full-page photographs of flowering or fruiting plants. Nomenclature revised by Edward G. Voss. One of few works concerned with shrubs. 205 plates, 35 drawings. xxviii + 521pp. 21989-5 Paperbound $3.75

The Mushroom Handbook, Louis C. C. Krieger. Still the best popular handbook: full descriptions of 259 species, cross references to another 200. Extremely thorough text enables you to identify, know all about any mushroom you are likely to meet in eastern and central U. S. A.: habitat, luminescence, poisonous qualities, use, folklore, etc. 32 color plates show over 50 mushrooms, also 126 other illustrations. Finding keys. vii + 560pp. 21861-9 Paperbound $3.95

Handbook of Birds of Eastern North America, Frank M. Chapman. Still much the best single-volume guide to the birds of Eastern and Central United States. Very full coverage of 675 species, with descriptions, life habits, distribution, similar data. All descriptions keyed to two-page color chart. With this single volume the average birdwatcher needs no other books. 1931 revised edition. 195 illustrations. xxxvi + 581pp. 21489-3 Paperbound $5.00

PLANETS, STARS AND GALAXIES: DESCRIPTIVE ASTRONOMY FOR BEGINNERS, A. E. Fanning. Comprehensive introductory survey of astronomy: the sun, solar system, stars, galaxies, universe, cosmology; up-to-date, including quasars, radio stars, etc. Preface by Prof. Donald Menzel. 24pp. of photographs. 189pp. 5¼ x 8¼.

21680-2 Paperbound $1.75

TEACH YOURSELF CALCULUS, P. Abbott. With a good background in algebra and trig, you can teach yourself calculus with this book. Simple, straightforward introduction to functions of all kinds, integration, differentiation, series, etc. "Students who are beginning to study calculus method will derive great help from this book." Faraday House Journal. 308pp. 20683-1 Clothbound $2.50

TEACH YOURSELF TRIGONOMETRY, P. Abbott. Geometrical foundations, indices and logarithms, ratios, angles, circular measure, etc. are presented in this sound, easy-to-use text. Excellent for the beginner or as a brush up, this text carries the student through the solution of triangles. 204pp. 20682-3 Clothbound $2.50

BASIC MACHINES AND HOW THEY WORK, U. S. Bureau of Naval Personnel. Originally used in U.S. Naval training schools, this book clearly explains the operation of a progression of machines, from the simplest—lever, wheel and axle, inclined plane, wedge, screw—to the most complex—typewriter, internal combustion engine, computer mechanism. Utilizing an approach that requires only an elementary understanding of mathematics, these explanations build logically upon each other and are assisted by over 200 drawings and diagrams. Perfect as a technical school manual or as a self-teaching aid to the layman. 204 figures. Preface. Index. vii + 161pp. 6½ x 9¼. 21709-4 Paperbound $2.50

THE FRIENDLY STARS, Martha Evans Martin. Classic has taught naked-eye observation of stars, planets to hundreds of thousands, still not surpassed for charm, lucidity, adequacy. Completely updated by Professor Donald H. Menzel, Harvard Observatory. 25 illustrations. 16 x 30 chart. x + 147pp. 21099-5 Paperbound $1.50

MUSIC OF THE SPHERES: THE MATERIAL UNIVERSE FROM ATOM TO QUASAR, SIMPLY EXPLAINED, Guy Murchie. Extremely broad, brilliantly written popular account begins with the solar system and reaches to dividing line between matter and nonmatter; latest understandings presented with exceptional clarity. Volume One: Planets, stars, galaxies, cosmology, geology, celestial mechanics, latest astronomical discoveries; Volume Two: Matter, atoms, waves, radiation, relativity, chemical action, heat, nuclear energy, quantum theory, music, light, color, probability, antimatter, antigravity, and similar topics. 319 figures. 1967 (second) edition. Total of xx + 644pp. 21809-0, 21810-4 Two volumes, Paperbound $5.50

OLD-TIME SCHOOLS AND SCHOOL BOOKS, Clifton Johnson. Illustrations and rhymes from early primers, abundant quotations from early textbooks, many anecdotes of school life enliven this study of elementary schools from Puritans to middle 19th century. Introduction by Carl Withers. 234 illustrations. xxxiii + 381pp.

21031-6 Paperbound $3.50

THE PHILOSOPHY OF THE UPANISHADS, Paul Deussen. Clear, detailed statement of upanishadic system of thought, generally considered among best available. History of these works, full exposition of system emergent from them, parallel concepts in the West. Translated by A. S. Geden. xiv + 429pp.
21616-0 Paperbound $3.50

LANGUAGE, TRUTH AND LOGIC, Alfred J. Ayer. Famous, remarkably clear introduction to the Vienna and Cambridge schools of Logical Positivism; function of philosophy, elimination of metaphysical thought, nature of analysis, similar topics. "Wish I had written it myself," Bertrand Russell. 2nd, 1946 edition. 160pp.
20010-8 Paperbound $1.50

THE GUIDE FOR THE PERPLEXED, Moses Maimonides. Great classic of medieval Judaism, major attempt to reconcile revealed religion (Pentateuch, commentaries) and Aristotelian philosophy. Enormously important in all Western thought. Unabridged Friedländer translation. 50-page introduction. lix + 414pp.
(USO) 20351-4 Paperbound $3.50

OCCULT AND SUPERNATURAL PHENOMENA, D. H. Rawcliffe. Full, serious study of the most persistent delusions of mankind: crystal gazing, mediumistic trance, stigmata, lycanthropy, fire walking, dowsing, telepathy, ghosts, ESP, etc., and their relation to common forms of abnormal psychology. Formerly *Illusions and Delusions of the Supernatural and the Occult*. iii + 551pp. 20503-7 Paperbound $3.50

THE EGYPTIAN BOOK OF THE DEAD: THE PAPYRUS OF ANI, E. A. Wallis Budge. Full hieroglyphic text, interlinear transliteration of sounds, word for word translation, then smooth, connected translation; Theban recension. Basic work in Ancient Egyptian civilization; now even more significant than ever for historical importance, dilation of consciousness, etc. clvi + 377pp. 6½ x 9¼.
21866-X Paperbound $3.95

PSYCHOLOGY OF MUSIC, Carl E. Seashore. Basic, thorough survey of everything known about psychology of music up to 1940's; essential reading for psychologists, musicologists. Physical acoustics; auditory apparatus; relationship of physical sound to perceived sound; role of the mind in sorting, altering, suppressing, creating sound sensations; musical learning, testing for ability, absolute pitch, other topics. Records of Caruso, Menuhin analyzed. 88 figures. xix + 408pp.
21851-1 Paperbound $3.50

THE I CHING (THE BOOK OF CHANGES), translated by James Legge. Complete translated text plus appendices by Confucius, of perhaps the most penetrating divination book ever compiled. Indispensable to all study of early Oriental civilizations. 3 plates. xxiii + 448pp. 21062-6 Paperbound $3.00

THE UPANISHADS, translated by Max Müller. Twelve classical upanishads: Chandogya, Kena, Aitareya, Kaushitaki, Isa, Katha, Mundaka, Taittiriyaka, Brhadaranyaka, Svetasvatara, Prasna, Maitriyana. 160-page introduction, analysis by Prof. Müller. Total of 670pp. 20992-X, 20993-8 Two volumes, Paperbound $6.50

JIM WHITEWOLF: THE LIFE OF A KIOWA APACHE INDIAN, Charles S. Brant, editor. Spans transition between native life and acculturation period, 1880 on. Kiowa culture, personal life pattern, religion and the supernatural, the Ghost Dance, breakdown in the White Man's world, similar material. 1 map. xii + 144pp.
22015-X Paperbound $1.75

THE NATIVE TRIBES OF CENTRAL AUSTRALIA, Baldwin Spencer and F. J. Gillen. Basic book in anthropology, devoted to full coverage of the Arunta and Warramunga tribes; the source for knowledge about kinship systems, material and social culture, religion, etc. Still unsurpassed. 121 photographs, 89 drawings. xviii + 669pp.
21775-2 Paperbound $5.00

MALAY MAGIC, Walter W. Skeat. Classic (1900); still the definitive work on the folklore and popular religion of the Malay peninsula. Describes marriage rites, birth spirits and ceremonies, medicine, dances, games, war and weapons, etc. Extensive quotes from original sources, many magic charms translated into English. 35 illustrations. Preface by Charles Otto Blagden. xxiv + 685pp.
21760-4 Paperbound $4.00

HEAVENS ON EARTH: UTOPIAN COMMUNITIES IN AMERICA, 1680-1880, Mark Holloway. The finest nontechnical account of American utopias, from the early Woman in the Wilderness, Ephrata, Rappites to the enormous mid 19th-century efflorescence; Shakers, New Harmony, Equity Stores, Fourier's Phalanxes, Oneida, Amana, Fruitlands, etc. "Entertaining and very instructive." *Times Literary Supplement.* 15 illustrations. 246pp.
21593-8 Paperbound $2.00

LONDON LABOUR AND THE LONDON POOR, Henry Mayhew. Earliest (c. 1850) sociological study in English, describing myriad subcultures of London poor. Particularly remarkable for the thousands of pages of direct testimony taken from the lips of London prostitutes, thieves, beggars, street sellers, chimney-sweepers, street-musicians, "mudlarks," "pure-finders," rag-gatherers, "running-patterers," dock laborers, cab-men, and hundreds of others, quoted directly in this massive work. An extraordinarily vital picture of London emerges. 110 illustrations. Total of lxxvi + 1951pp. 6⅝ x 10.
21934-8, 21935-6, 21936-4, 21937-2 Four volumes, Paperbound $16.00

HISTORY OF THE LATER ROMAN EMPIRE, J. B. Bury. Eloquent, detailed reconstruction of Western and Byzantine Roman Empire by a major historian, from the death of Theodosius I (395 A.D.) to the death of Justinian (565). Extensive quotations from contemporary sources; full coverage of important Roman and foreign figures of the time. xxxiv + 965pp. 20398-0, 20399-9 Two volumes, Paperbound $7.00

AN INTELLECTUAL AND CULTURAL HISTORY OF THE WESTERN WORLD, Harry Elmer Barnes. Monumental study, tracing the development of the accomplishments that make up human culture. Every aspect of man's achievement surveyed from its origins in the Paleolithic to the present day (1964); social structures, ideas, economic systems, art, literature, technology, mathematics, the sciences, medicine, religion, jurisprudence, etc. Evaluations of the contributions of scores of great men. 1964 edition, revised and edited by scholars in the many fields represented. Total of xxix + 1381pp.
21275-0, 21276-9, 21277-7 Three volumes, Paperbound $10.50

AMERICAN FOOD AND GAME FISHES, David S. Jordan and Barton W. Evermann. Definitive source of information, detailed and accurate enough to enable the sportsman and nature lover to identify conclusively some 1,000 species and sub-species of North American fish, sought for food or sport. Coverage of range, physiology, habits, life history, food value. Best methods of capture, interest to the angler, advice on bait, fly-fishing, etc. 338 drawings and photographs. 1 + 574pp. 6⅝ x 9⅜.
22383-1 Paperbound $4.50

THE FROG BOOK, Mary C. Dickerson. Complete with extensive finding keys, over 300 photographs, and an introduction to the general biology of frogs and toads, this is the classic non-technical study of Northeastern and Central species. 58 species; 290 photographs and 16 color plates. xvii + 253pp.
21973-9 Paperbound $4.00

THE MOTH BOOK: A GUIDE TO THE MOTHS OF NORTH AMERICA, William J. Holland. Classical study, eagerly sought after and used for the past 60 years. Clear identification manual to more than 2,000 different moths, largest manual in existence. General information about moths, capturing, mounting, classifying, etc., followed by species by species descriptions. 263 illustrations plus 48 color plates show almost every species, full size. 1968 edition, preface, nomenclature changes by A. E. Brower. xxiv + 479pp. of text. 6½ x 9¼.
21948-8 Paperbound $5.00

THE SEA-BEACH AT EBB-TIDE, Augusta Foote Arnold. Interested amateur can identify hundreds of marine plants and animals on coasts of North America; marine algae; seaweeds; squids; hermit crabs; horse shoe crabs; shrimps; corals; sea anemones; etc. Species descriptions cover: structure; food; reproductive cycle; size; shape; color; habitat; etc. Over 600 drawings. 85 plates. xii + 490pp.
21949-6 Paperbound $3.50

COMMON BIRD SONGS, Donald J. Borror. 33⅓ 12-inch record presents songs of 60 important birds of the eastern United States. A thorough, serious record which provides several examples for each bird, showing different types of song, individual variations, etc. Inestimable identification aid for birdwatcher. 32-page booklet gives text about birds and songs, with illustration for each bird.
21829-5 Record, book, album. Monaural. $2.75

FADS AND FALLACIES IN THE NAME OF SCIENCE, Martin Gardner. Fair, witty appraisal of cranks and quacks of science: Atlantis, Lemuria, hollow earth, flat earth, Velikovsky, orgone energy, Dianetics, flying saucers, Bridey Murphy, food fads, medical fads, perpetual motion, etc. Formerly "In the Name of Science." x + 363pp.
20394-8 Paperbound $2.00

HOAXES, Curtis D. MacDougall. Exhaustive, unbelievably rich account of great hoaxes: Locke's moon hoax, Shakespearean forgeries, sea serpents, Loch Ness monster, Cardiff giant, John Wilkes Booth's mummy, Disumbrationist school of art, dozens more; also journalism, psychology of hoaxing. 54 illustrations. xi + 338pp.
20465-0 Paperbound $2.75

DESIGN BY ACCIDENT; A BOOK OF "ACCIDENTAL EFFECTS" FOR ARTISTS AND DESIGNERS, James F. O'Brien. Create your own unique, striking, imaginative effects by "controlled accident" interaction of materials: paints and lacquers, oil and water based paints, splatter, crackling materials, shatter, similar items. Everything you do will be different; first book on this limitless art, so useful to both fine artist and commercial artist. Full instructions. 192 plates showing "accidents," 8 in color. viii + 215pp. 8⅜ x 11¼. 21942-9 Paperbound $3.50

THE BOOK OF SIGNS, Rudolf Koch. Famed German type designer draws 493 beautiful symbols: religious, mystical, alchemical, imperial, property marks, runes, etc. Remarkable fusion of traditional and modern. Good for suggestions of timelessness, smartness, modernity. Text. vi + 104pp. 6⅛ x 9¼.
20162-7 Paperbound $1.25

HISTORY OF INDIAN AND INDONESIAN ART, Ananda K. Coomaraswamy. An unabridged republication of one of the finest books by a great scholar in Eastern art. Rich in descriptive material, history, social backgrounds; Sunga reliefs, Rajput paintings, Gupta temples, Burmese frescoes, textiles, jewelry, sculpture, etc. 400 photos. viii + 423pp. 6⅜ x 9¾. 21436-2 Paperbound $4.00

PRIMITIVE ART, Franz Boas. America's foremost anthropologist surveys textiles, ceramics, woodcarving, basketry, metalwork, etc.; patterns, technology, creation of symbols, style origins. All areas of world, but very full on Northwest Coast Indians. More than 350 illustrations of baskets, boxes, totem poles, weapons, etc. 378 pp.
20025-6 Paperbound $3.00

THE GENTLEMAN AND CABINET MAKER'S DIRECTOR, Thomas Chippendale. Full reprint (third edition, 1762) of most influential furniture book of ·all time, by master cabinetmaker. 200 plates, illustrating chairs, sofas, mirrors, tables, cabinets, plus 24 photographs of surviving pieces. Biographical introduction by N. Bienenstock. vi + 249pp. 9⅞ x 12¾. 21601-2 Paperbound $4.00

AMERICAN ANTIQUE FURNITURE, Edgar G. Miller, Jr. The basic coverage of all American furniture before 1840. Individual chapters cover type of furniture— clocks, tables, sideboards, etc.—chronologically, with inexhaustible wealth of data. More than 2100 photographs, all identified, commented on. Essential to all early American collectors. Introduction by H. E. Keyes. vi + 1106pp. 7⅞ x 10¾.
21599-7, 21600-4 Two volumes, Paperbound $11.00

PENNSYLVANIA DUTCH AMERICAN FOLK ART, Henry J. Kauffman. 279 photos, 28 drawings of tulipware, Fraktur script, painted tinware, toys, flowered furniture, quilts, samplers, hex signs, house interiors, etc. Full descriptive text. Excellent for tourist, rewarding for designer, collector. Map. 146pp. 7⅞ x 10¾.
21205-X Paperbound $2.50

EARLY NEW ENGLAND GRAVESTONE RUBBINGS, Edmund V. Gillon, Jr. 43 photographs, 226 carefully reproduced rubbings show heavily symbolic, sometimes macabre early gravestones, up to early 19th century. Remarkable early American primitive art, occasionally strikingly beautiful; always powerful. Text. xxvi + 207pp. 8⅜ x 11¼. 21380-3 Paperbound $3.50

VISUAL ILLUSIONS: THEIR CAUSES, CHARACTERISTICS, AND APPLICATIONS, Matthew Luckiesh. Thorough description and discussion of optical illusion, geometric and perspective, particularly; size and shape distortions, illusions of color, of motion; natural illusions; use of illusion in art and magic, industry, etc. Most useful today with op art, also for classical art. Scores of effects illustrated. Introduction by William H. Ittleson. 100 illustrations. xxi + 252pp.
21530-X Paperbound $2.00

A HANDBOOK OF ANATOMY FOR ART STUDENTS, Arthur Thomson. Thorough, virtually exhaustive coverage of skeletal structure, musculature, etc. Full text, supplemented by anatomical diagrams and drawings and by photographs of undraped figures. Unique in its comparison of male and female forms, pointing out differences of contour, texture, form. 211 figures, 40 drawings, 86 photographs. xx + 459pp. 5⅜ x 8⅜.
21163-0 Paperbound $3.50

150 MASTERPIECES OF DRAWING, Selected by Anthony Toney. Full page reproductions of drawings from the early 16th to the end of the 18th century, all beautifully reproduced: Rembrandt, Michelangelo, Dürer, Fragonard, Urs, Graf, Wouwerman, many others. First-rate browsing book, model book for artists. xviii + 150pp. 8⅜ x 11¼.
21032-4 Paperbound $2.50

THE LATER WORK OF AUBREY BEARDSLEY, Aubrey Beardsley. Exotic, erotic, ironic masterpieces in full maturity: Comedy Ballet, Venus and Tannhauser, Pierrot, Lysistrata, Rape of the Lock, Savoy material, Ali Baba, Volpone, etc. This material revolutionized the art world, and is still powerful, fresh, brilliant. With *The Early Work,* all Beardsley's finest work. 174 plates, 2 in color. xiv + 176pp. 8⅛ x 11.
21817-1 Paperbound $3.00

DRAWINGS OF REMBRANDT, Rembrandt van Rijn. Complete reproduction of fabulously rare edition by Lippmann and Hofstede de Groot, completely reedited, updated, improved by Prof. Seymour Slive, Fogg Museum. Portraits, Biblical sketches, landscapes, Oriental types, nudes, episodes from classical mythology—All Rembrandt's fertile genius. Also selection of drawings by his pupils and followers. "Stunning volumes," *Saturday Review.* 550 illustrations. lxxviii + 552pp. 9⅛ x 12¼.
21485-0, 21486-9 Two volumes, Paperbound $10.00

THE DISASTERS OF WAR, Francisco Goya. One of the masterpieces of Western civilization—83 etchings that record Goya's shattering, bitter reaction to the Napoleonic war that swept through Spain after the insurrection of 1808 and to war in general. Reprint of the first edition, with three additional plates from Boston's Museum of Fine Arts. All plates facsimile size. Introduction by Philip Hofer, Fogg Museum. v + 97pp. 9⅜ x 8¼.
21872-4 Paperbound $2.00

GRAPHIC WORKS OF ODILON REDON. Largest collection of Redon's graphic works ever assembled: 172 lithographs, 28 etchings and engravings, 9 drawings. These include some of his most famous works. All the plates from *Odilon Redon: oeuvre graphique complet,* plus additional plates. New introduction and caption translations by Alfred Werner. 209 illustrations. xxvii + 209pp. 9⅛ x 12¼.
21966-8 Paperbound $4.00

TWO LITTLE SAVAGES; BEING THE ADVENTURES OF TWO BOYS WHO LIVED AS INDIANS AND WHAT THEY LEARNED, Ernest Thompson Seton. Great classic of nature and boyhood provides a vast range of woodlore in most palatable form, a genuinely entertaining story. Two farm boys build a teepee in woods and live in it for a month, working out Indian solutions to living problems, star lore, birds and animals, plants, etc. 293 illustrations. vii + 286pp.

20985-7 Paperbound $2.50

PETER PIPER'S PRACTICAL PRINCIPLES OF PLAIN & PERFECT PRONUNCIATION. Alliterative jingles and tongue-twisters of surprising charm, that made their first appearance in America about 1830. Republished in full with the spirited woodcut illustrations from this earliest American edition. 32pp. 4½ x 6⅜.

22560-7 Paperbound $1.00

SCIENCE EXPERIMENTS AND AMUSEMENTS FOR CHILDREN, Charles Vivian. 73 easy experiments, requiring only materials found at home or easily available, such as candles, coins, steel wool, etc.; illustrate basic phenomena like vacuum, simple chemical reaction, etc. All safe. Modern, well-planned. Formerly *Science Games for Children.* 102 photos, numerous drawings. 96pp. 6⅛ x 9¼.

21856-2 Paperbound $1.25

AN INTRODUCTION TO CHESS MOVES AND TACTICS SIMPLY EXPLAINED, Leonard Barden. Informal intermediate introduction, quite strong in explaining reasons for moves. Covers basic material, tactics, important openings, traps, positional play in middle game, end game. Attempts to isolate patterns and recurrent configurations. Formerly *Chess.* 58 figures. 102pp. (USO) 21210-6 Paperbound $1.25

LASKER'S MANUAL OF CHESS, Dr. Emanuel Lasker. Lasker was not only one of the five great World Champions, he was also one of the ablest expositors, theorists, and analysts. In many ways, his Manual, permeated with his philosophy of battle, filled with keen insights, is one of the greatest works ever written on chess. Filled with analyzed games by the great players. A single-volume library that will profit almost any chess player, beginner or master. 308 diagrams. xli x 349pp.

20640-8 Paperbound $2.75

THE MASTER BOOK OF MATHEMATICAL RECREATIONS, Fred Schuh. In opinion of many the finest work ever prepared on mathematical puzzles, stunts, recreations; exhaustively thorough explanations of mathematics involved, analysis of effects, citation of puzzles and games. Mathematics involved is elementary. Translated by F. Göbel. 194 figures. xxiv + 430pp.

22134-2 Paperbound $3.00

MATHEMATICS, MAGIC AND MYSTERY, Martin Gardner. Puzzle editor for Scientific American explains mathematics behind various mystifying tricks: card tricks, stage "mind reading," coin and match tricks, counting out games, geometric dissections, etc. Probability sets, theory of numbers clearly explained. Also provides more than 400 tricks, guaranteed to work, that you can do. 135 illustrations. xii + 176pp.

20338-2 Paperbound $1.50

MATHEMATICAL PUZZLES FOR BEGINNERS AND ENTHUSIASTS, Geoffrey Mott-Smith. 189 puzzles from easy to difficult—involving arithmetic, logic, algebra, properties of digits, probability, etc.—for enjoyment and mental stimulus. Explanation of mathematical principles behind the puzzles. 135 illustrations. viii + 248pp.
20198-8 Paperbound $1.75

PAPER FOLDING FOR BEGINNERS, William D. Murray and Francis J. Rigney. Easiest book on the market, clearest instructions on making interesting, beautiful origami. Sail boats, cups, roosters, frogs that move legs, bonbon boxes, standing birds, etc. 40 projects; more than 275 diagrams and photographs. 94pp.
20713-7 Paperbound $1.00

TRICKS AND GAMES ON THE POOL TABLE, Fred Herrmann. 79 tricks and games—some solitaires, some for two or more players, some competitive games—to entertain you between formal games. Mystifying shots and throws, unusual caroms, tricks involving such props as cork, coins, a hat, etc. Formerly *Fun on the Pool Table*. 77 figures. 95pp.
21814-7 Paperbound $1.00

HAND SHADOWS TO BE THROWN UPON THE WALL: A SERIES OF NOVEL AND AMUSING FIGURES FORMED BY THE HAND, Henry Bursill. Delightful picturebook from great-grandfather's day shows how to make 18 different hand shadows: a bird that flies, duck that quacks, dog that wags his tail, camel, goose, deer, boy, turtle, etc. Only book of its sort. vi + 33pp. 6½ x 9¼. 21779-5 Paperbound $1.00

WHITTLING AND WOODCARVING, E. J. Tangerman. 18th printing of best book on market. "If you can cut a potato you can carve" toys and puzzles, chains, chessmen, caricatures, masks, frames, woodcut blocks, surface patterns, much more. Information on tools, woods, techniques. Also goes into serious wood sculpture from Middle Ages to present, East and West. 464 photos, figures. x + 293pp.
20965-2 Paperbound $2.00

HISTORY OF PHILOSOPHY, Julián Marias. Possibly the clearest, most easily followed, best planned, most useful one-volume history of philosophy on the market; neither skimpy nor overfull. Full details on system of every major philosopher and dozens of less important thinkers from pre-Socratics up to Existentialism and later. Strong on many European figures usually omitted. Has gone through dozens of editions in Europe. 1966 edition, translated by Stanley Appelbaum and Clarence Strowbridge. xviii + 505pp. 21739-6 Paperbound $3.00

YOGA: A SCIENTIFIC EVALUATION, Kovoor T. Behanan. Scientific but non-technical study of physiological results of yoga exercises; done under auspices of Yale U. Relations to Indian thought, to psychoanalysis, etc. 16 photos. xxiii + 270pp.
20505-3 Paperbound $2.50